Good Day Today

David Lynch Destabilises the Spectator

Good Day Today

David Lynch Destabilises the Spectator

Daniel Neofetou

Winchester, UK
Washington, USA

First published by Zero Books, 2012
Zero Books is an imprint of John Hunt Publishing Ltd., Laurel House, Station Approach,
Alresford, Hants, SO24 9JH, UK
office1@jhpbooks.net
www.johnhuntpublishing.com
www.zero-books.net

For distributor details and how to order please visit the 'Ordering' section on our website.

Text copyright: Daniel Neofetou 2012

ISBN: 978 1 78099 767 4

A CIP catalogue record for this book is available from the British Library.

Design: Stuart Davies

Printed and bound by CPI Group (UK) Ltd, Croydon, CR0 4YY

We operate a distinctive and ethical publishing philosophy in all
areas of our business, from our global network of authors to
production and worldwide distribution.

CONTENTS

This book is dedicated to my family, friends, well-wishers and academic equals or superiors past and present; to Mum, Dad, Katie, Granny & Grandpa, Hamish, Ollie, Giles, Wendy and the rest of my family; to Jon, Kris, James, Jonny, Reem, J.V., Mike, Luke, Tête & Krystal, Fil, Tali, Calpal, Ben, Tribes, Dan M, Dan B, Henry Lau, Kevin & the pigeons, Jason, J. Nunn & S. Edmondson, Nick Chen, Bosborn & Nina, Hilsdon, Brutal Powell, Kendo and the rest of my Warwick Uni pals; from my year at Edinburgh (during which this book was conceived and written as a dissertation): Baz, Marty, Marcus, Sean, Gao Gao, Alice, Heath, Oli; to all the White Cube invigilators; to tutors I've had through the years who exposed me to ideas which informed this book, such as Helmut Schmitz, Michael Gardiner, Jose Arroyo, Charlotte Brunsdon, Matine Beugnet and Dan Yacavone; to all the (mostly dead) people whose writing has inspired me. And to Leah.

Introduction

A few years ago I was working on a short film which one of my friends was directing. During shooting, a lot of the cast and crew were staying at his house, and one night a few of us decided to watch David Lynch's *Eraserhead* (1977). By the time the lady in the radiator with lumpy hamster-pouch cheeks performed her foetus-stomping routine, one actor became incredibly frustrated and protested that the film didn't make any sense. I replied with something like 'It doesn't need to make sense. Just watch it', and a few scenes later, he said 'It makes a lot more sense now that I know it doesn't need to make sense.'

This anecdote serves as an example – however minimal – of the way in which Lynch's films might change the way a spectator thinks about cultural norms. In this case, *Eraserhead* engendered the realisation that films don't *need* to make sense. However, due to its mimetic nature, film is a medium which often works to support cultural norms beyond its concerns as an art-form more so than any other. A pop song might instantiate verse-chorus form or the chromatic scale as somehow natural, yet a film might not only reinforce the rules of continuity editing as natural, but also the 'rules' of current society. It is therefore conceivable that, in terms of films which destabilise their spectator and all but demand a new mode of reception, the inverse is also possible, and the spectator who realises that films don't *need* to make sense, might realise that many other aspects of life which he/she takes as given do not *need* to be so.

The notion that film might serve this revolutionarily emancipatory purpose through spectatorial destabilisation is especially crucial now, when the unashamed imposition of ideology by those in power is particularly vigorous. Beyond mass market advertising, whose aggressive promotion of normativity is of course a constant under late capitalism, this is evident in two

speeches made by David Cameron, one at a Witney youth centre in the aftermath of the 2011 summer riots across the UK, and another made in December of the same year to the Church of England clergy in Oxford. In the latter, he referred to a (biblical) 'set of values and morals which make Britain what it is today' and blamed virtually every element of social unrest and corruption in banking and politics (all of which, according to Cameron, was obviously the work of errant agents rather than product of the systems themselves) on the dissolution of said set of values and morals. This point of view is one which he espoused to greater – and more insidious – length in the former speech, in which he proclaimed that 'we have been unwilling for too long to talk about what is right and what is wrong', as if the world – or the nation, even – had come to some sort of consensus in these matters.

This appeal to a notional essentialist moral code was not uncommon during the 2011 summer riots, and one of the most obscene examples was provided by Edwina Currie on Newsnight, when she conflated the values of market capitalism with such a supposed code in a clunky rhetorical manoeuvre. 'This is not the behaviour of a group of people who have any kind of morality', she harped, arguing that the reasons for the disorder did not lie with disenfranchised youth being 'disconnected from jobs or whatever', but instead asserting that the riots were product of these people's disconnection 'from any real sense of right and wrong: any real sense that says what's mine is mine and what's yours is yours, and I don't touch it', as if the concept of private property isn't simply a contingency of capitalism, and has anything to do with 'a *real* sense of right and wrong.'

In both the speech to the youth centre and the speech to the Church of England clergy, with almost precisely the same wording, Cameron made the grand concluding statement that 'this moral neutrality, this relativism [is] not going to cut it anymore.' But if relativism has proved itself insufficient for

Cameron, is the implication that moral absolutism is the answer? It is not as if the representations serving the interests of certain of society's strata are not already hypostasized and the oppressed obfuscated by the dominant discourse in its presentation of 'the way things are'; it is not as if it is not already the case that our 'supposedly universal international law…cannot be dissociated from certain European philosophical concepts' (Derrida, 83). However, the fact that, at the time of writing this introduction, the prime minister of Britain seems to be – quite unambiguously – laying the foundation for one-size-fits-all authoritarian lifestyle guidelines means that now is a moment when the cultivation of a mindset which refuses to accept norms as pre-given is more crucial than ever, and throughout this book, I argue that the films of David Lynch are well suited to cultivate such a mindset.

A Reproduction of the Image of Life

Serious discussion of film's capacity to essentialise cultural norms – and, thereby, the notion that the inverse might also be possible – first arose in the post-1968 'argument between a politics of subject matter and a politics of subjectivity' primarily forwarded and debated in the pages of *Screen* and in the lively contestation of The London Film-Maker's Co-op (Caughie, 106). Premises which arose in these forums pose the conventional feature film as aligned with normalising ideology by its mode of address alone, and one of the most convincing and theoretically rigorous documents from this time is Colin Maccabe's essay *Realism and the Cinema*. In this essay, Maccabe refers to the conventional feature film as 'classic realist.' He defines as classic realist any artwork – whether it be a film, painting, book or play – which purports to present 'some fixed reality...from an objective point of view' which is 'beyond argument' (42-49). Maccabe argues that classic realist works thereby present contingency as pre-given, and that crucial to this normalisation is the third-person address, which Maccabe refers to as the text's metalanguage. In classic realist literature, this metalanguage is comprised of the words within fiction's prose which are not enclosed within quotation marks, and which might therefore discuss the veracity of the words within the prose which *are* enclosed within quotation marks. This metalanguage 'simply allows reality to appear', and thereby is not open to reinterpretation (Maccabe, 36).

In the classic realist film, asserts Maccabe, this metalanguage - the 'truth against which we can measure the discourses' - is provided by the camera, which 'is not articulated as part of the productive process of the film' (37). As he elaborates, 'the knowledge which the film provides of how things really are...is the metalanguage in which we can talk of the various characters

in the film' (Maccabe, 38), and this is undeniably the case. Unless it is vigorously signposted as thus – in the case of, for example, a dream or fantasy sequence of one of the characters within the film's diegesis – that which the classic realist film shows us is never in question. We are presented with a series of images which assert themselves as cumulative to the cultivation of, in the words of Andre Bazin, 'an integral realism, a recreation of the world in its own image, an image unburdened by the freedom of interpretation of the artist or the irreversibility of time' (36).

This mode of filmmaking, then, ostensibly places its spectator in a position of unproblematic omniscience[1], and thereby 'entails that the only problem that reality poses is to go and look and see what *things* there are' because it presents reality as 'not articulated' (Maccabe, 39). In doing so, Maccabe and many of his contemporaries argue that its address 'imposes as "truth" the vision of the world entertained by a certain class'(Dayan, 184), disavowing its subjective nature and hypostasizing its representations. Fundamentally, they posit that, 'instead of holding to a reproduction of life', the classic realist film 'holds to a reproduction of the image of life' (Heath, 4).

Central to this problematic is the manner in which, despite the archetypal classic realist film's mode of address refusing 'its status as discourse (as articulation), in favour of its self-presentation of simply identity, complete knowledge' (Maccabe, 69), it cultivates this apparently objective omniscience through effecting 'a choice in what it describes', and elucidating its diegesis with 'certain scenes rather than others' (Godard, 222). It primarily engenders a mode of reception based on an 'intricate concern with the consequences' of characters' actions (Le Grice, 177). Thereby, while purportedly conveying a fictional world in its totality, the archetypal classic realist film's scenes are primarily of significance in terms of that which proceeds from and precedes them.

A pertinent parallel which can be drawn with the dominant

discourse here is in terms of its historiography. As Walter Benjamin argues in his celebrated essay *Theses on the Philosophy of History*, the historiography of the dominant discourse 'contends itself with establishing a causal connection between various moments' and disavows 'every image of the past that is not recognised by the present as one of its own concerns' (247-255). It is Benjamin's contention, then, that, while ostensibly objective, the historiography of the dominant discourse is in fact selective and serves the interests of those in power, primarily considering moments as nexuses in reference to a perceived outcome. Similarly - as I delineate above - the archetypal classic realist film engenders a mode of reception for which the value of each scene is largely dependent upon that which came before and, ultimately, the significance of each scene might be decisively judged in reference to the film's conclusion. Like the historiography of the dominant discourse, it is ostensibly objective, yet its apparent totality is composed of units whose concerns are narrow. Thereby, one might argue that the historiography of the dominant discourse and the classic realist film are both – as Roland Barthes writes of history and the classical novel in *Writing Degree Zero* – 'plane projections of a curved and organic world of which the serial story…presents…a degraded image' (35).

For scholars of the post-1968 leftist school of thought, then, the classic realist text 'works on the concealing of the dominant discourse as articulation' and 'presents itself exactly as the presentation of objects' by 'fixing the subject in a point of view from which everything becomes obvious' (Maccabe, 44 - 47). They posit that the mode of reception engendered by the classic realist film - a mode of reception which does not question the fundamental norms of the film's world - is mirrored by a mindset which experiences the 'real world' without 'recognition of the imposition of ideologies' (Gidal, 11).

However, these formulations have been met with harsh criticism. In his essay *Against "The System of the Suture"*, for

example, William Rothman argues against such theories, putting forward the following conclusions:

> The commonsense position would appear to be that "classical cinema" has through its complex history served a variety of masters. "Classical" films, to be sure, have in countless cases served many different forms of *bourgeois* ideology. But they have also been instrumental in concrete attacks on particular ideological forms. Nor has...anything [ruled] out the possibility that there have been "classical" films that were their own masters. (198)

I would argue, however, that Rothman simply does not harbour the discontent with the status quo which is necessary for one to reach absolutist assertions concerning the classic realist film's collusion with the dominant discourse. For Rothman, the variegated content of different classic realist films is apparently enough to make the claim that their mode of address is self-same – or that this mode of address is that which is problematic – appear absurd.

A similar satisfaction with the status quo limits David Bordwell's engagement with such arguments. Specifically countering Maccabe's essay, Bordwell posits that to claim that all films which present a narrative in a coherent diegesis from the third-person perspective are ideologically mediated 'only to grant that most films "efface" or "conceal" this process', is pointless (62). Bordwell affirms that a 'spectator should construct a narrator' only when the film signals under certain circumstances that one must do so (62), and thereby only sees the necessity to discern an articulator when that articulator is presumed to be part of the diegesis. In this approach, there is little hope of querying the fundamental norms of a film's fictional world, but it is doubtful that Bordwell considers the querying of the dominant discourse's fundamental norms a

necessity either. However, if we *do* accept that the dominant discourse's effacement of ideology is problematic, I think essays such as Maccabe's remain pertinent in their highlighting of parallels between the mode of reception engendered by the classic realist text and the passive internalisation/reproduction of norms as pre-given which is engendered by the dominant discourse.

If we consider these analogues to be valid, then, and accept that the placement of the spectator as third-person theoretically renders film incapable of challenging established modes of thought, it follows that films might avoid such an impasse by placing the spectator as first-person, in a position which lacks the comfort of stabilised knowledge and values elements primarily for their audiovisual texture and multitudinous connotation as opposed to some fixed significance. In his work on David Lynch's *Lost Highway* (1997), Slavoj Žižek derides an appreciation of film which is based upon that which he refers to as a 'leftist, anarchic-obscurantist...insistence that one should renounce all interpretive effort and let ourselves go to the full ambiguity and richness [of] audio and visual texture' (17), but surely this is a mode of reception which resists the passive internalisation of cultural norms as essential to a greater extent than any other.

David Lynch has never displayed particularly leftist political impetus behind his filmmaking. This is a man who - at one time - 'was incapable of an intellectual discussion...and ate only at McDonald's' (Chion, 38), and who is prone to such self-effacing homilies as 'if I told you I was enlightened, and this is enlightened filmmaking, that would be another story. But I'm just a guy from Missoula, Montana, doing my thing, going down the road like everybody else' (91). Yet Lynch's first film, *Six Figures* (1966), quite overtly lends itself to such an emancipatory mode of reception. The film, originally projected onto a sculpted screen, depicts six partial figures vomiting as a siren rings out on the soundtrack. While the version which is currently in distribution

repeats this scene six times, the original looped indefinitely. Eric G. Wilson acknowledges that the film thwarts attempts to understand its action from the viewpoint of omniscience when he writes that 'regardless of how hard one tries to interpret this film, one in the end remains disarmed' (2), and one cannot draw parallels with the film's structure and the historiography of the dominant discourse either, since its scenes do not progress towards an endpoint. Instead, they relentlessly repeat the same action, thrillingly immersive but cumulative to nothing.

However, Lynch has proceeded to employ the visual rhetoric of the classic realist film in his work. In all his feature films, the action is formally presented from a third-person perspective - in that the camera itself is not articulated as a presence within the diegesis and yet there is no correspondence between its eye and a diegetic 'I' - and the scenes are largely composed as according to the dictates of an anthropocentric traversal of three-dimensional space. As Michel Chion writes, unlike *Six Figures*, Lynch's feature films do not ostensibly 'seek to revolutionise film language', and their 'syntax is fairly traditional' (39). They still, however, elicit a mode of reception averse to the mindset of the dominant discourse, to which many critical accounts attest. Chris Rodley, for instance, describes the experience of a Lynch film as 'primarily a sensory experience' which cannot be simply summarised in terms of 'the very nature of what one has seen' (ix - xi). He writes that Lynch 'deals in a direct way with ideas, images and feelings that make themselves known to him in ways other than the printed word': a destabilisation of taxonomical, fixed knowledge (xi).

By reading these quotes from Rodley, one might get the impression that Lynch's films bear no resemblance to the classic realist mode, and one could feasibly assume that Lynch's films were more formally radical than they actually are. Chion acknowledges such discrepancy between critical accounts and the films themselves when he refers to writers associating

9

Eraserhead 'with forms 'different' from ordinary cinema, to the point of concocting an imaginary film which no longer corresponds to what is on the screen'(40). Exemplary of this is Todd McGowan, who writes that *Lost Highway* is 'a difficult film to watch' (51). His reasoning behind this claim is that the film 'presents us with imagery so bright that we close our eyes or look away and with voices so distorted that we wish we could close our ears' (51) and yet - unless one's threshold of tolerance for sound and imagery is remarkably low - this is simply not the case.

It is true that Lynch's feature films are unconventional in terms of the commercial cinema, but they certainly do not completely eschew classic realist visual rhetoric, and throughout this book I endeavour to explore how the films of Lynch engender a mode of reception inimical to the dominant discourse, while still largely working within the formal paradigms of the classic realist film. In short, this book is an interrogation of the way in which Lynch's films engender the renunciation of 'all a priori interpretations of behaviour and facts' (Chion, 20), and yet do so through form which largely coheres with that of the classic realist text, a mode which theoretically *instantiates* a priori interpretations.

A Context Without Compass Points

As I delineate above, the classic realist film and the dominant discourse are significantly correlated by the third-person address in its obfuscation of the fact that 'reality' is itself an ideological articulation, and I posit that a film should place its audience in the first-person perspective if it is to efface this problem. Indeed, experimental filmmaking has often dealt very directly with the first-person perspective. For instance abstract film, which emancipates its content from explicit mimesis on the level of representation, all but forces a viewer to experience it as – to quote Stan Brakhage's *Metaphors on Vision* – 'an adventure of perception' (12). Another example is the diary film, for instance the oeuvre of Jonas Mekas, which is first-person in the most literal sense. A documentation of his life through the lens of a handheld Bolex which is 'as personal as handwriting' (Yue), Mekas's work's mode of address disavows omniscience and confesses its status as one subjectivity among many.

As I have acknowledged, however, Lynch's films ostensibly elucidate diegeses from a third-person perspective, appearing to employ all the formal techniques by which a metalanguage is established. I posit, however, that attempting to understand the scenes which this metalanguage conveys as cumulative to the exposition of a diegesis, in reference to which one might take a position of omniscience, is often futile, forcing the audience to perceive rather than understand. To return to Bordwell's writing on narration in the classic realist film, he appropriates two terms from Russian formalism, syuzhet and fabula. Bordwell writes that 'the fabula embodies the action as a chronological, cause-and-effect chain of events occurring within a given duration and a spatial field', while 'the syuzhet...is the actual arrangement and presentation of the fabula in the film' (49). Lynch's films, then, could often be said to have syuzhets without fabulas, with their

scenes composed in a manner which would appear to elucidate a diegetic reality, but which never does so to a satisfactorily coherent degree.

This marks his films, despite their largely conventional lexis, as aligned with experimental films which formally present their action from the third-person perspective but avoid the instantiation of norms as pre-given. For instance Andy Warhol's *Kitchen* (1965), of which Peter Gidal writes 'the diegesis...is not given as a logic of...any "true." There are no *a prioris*' (55); *Un Chien Andalou* (1929), which P. Adams Sitney states lacks 'final reference to a more conventional actuality' (14); and, most pertinently, Joseph Cornell's *Rose Hobart* (1936). Of these three films, *Rose Hobart* is the one which employs the rhetoric of the classic realist film to the greatest extent. This is because all of its footage is drawn from a classic realist film, the B-movie *East of Borneo* (1931). *East of Borneo*'s plot concerns a woman, Linda (Rose Hobart), searching for her husband. She travels to Borneo and finds her husband as the court physician of a Prince in a kingdom deep in the jungle. The Prince becomes smitten with Linda and does all he can to prevent her from leaving the island. Eventually, his amorous advances lead to her shooting him dead, a volcano on the island erupts and the woman and her husband escape unscathed.

In 1936, Cornell acquired a copy *East of Borneo* and re-edited it from 77 minutes to 20, removing the action sequences entirely and – working on the basis 'of sensibility, not of reasoning or ideology' (Vine, 37) – also removing almost all of the shots which did not feature Hobart to create *Rose Hobart*. In this process 'narrative sequence is reshuffled for purely poetic effect' (Vine, 47) in order that a new layer of affectivity in *East of Borneo*'s 'privileged moments' might be revealed (Ehrenstein, 38). Brian Frye writes that Cornell strips 'away the awkward construction and stilted drama of the original to reveal [a] wonderful sense of mystery' and this is certainly the case. While *East of Borneo* is now likely to invoke jovial derision, *Rose Hobart* still retains its

enigmatic power. As Sitney surmises, *Rose Hobart* 'is a breath-taking example of the potential for surrealistic imagery within a conventional Hollywood film once it is liberated from its narrative causality' (348).

Fundamentally, then, that the shots which comprise *Rose Hobart* are drawn from a firm diegetic universe has no bearing upon Cornell's intuitive ordering of the imagery. Due to their source, all of the scenes are composed as according to the dictates of classic realist visual rhetoric, yet they have been rearranged, and many scenes which were so crucial to *East of Borneo's* narrative are missing. In many of Lynch's films it often seems as if this is also the case, but in fact the order which the scenes are in is the only order, and the scenes which seem to be missing do not exist. This is particularly relevant in terms of *INLAND EMPIRE* (2006), which contains many scenes – particularly those set in Poland - which could be drawn from individual classic realist films, but which appear as fragments taken from nonexistent wholes, like artificial apple slices.

To an extent, then, these films urge their audiences 'toward an effort to retrieve the uninflected account of the events as they actually were, whatever they were' (Frampton, 188), but such endeavour presupposes that the films' syuzhets are drawn from pre-existing fabulas, which is not necessarily the case. Lynch himself addresses this issue directly when he claims in a DVD extra on the Region 2 release of *INLAND EMPIRE* that, in reference to that film, even though the manner in which the film's scenes are sequenced 'could seem deconstructed, that is the structure and that is the flow that gets the whole to feel correct.' If one assents to the notion that Lynch's films do not necessarily have fixed diegeses, claims such as Christopher J. Jarmick's assertion that *Mulholland Drive's* (2001) 'timeline of events is out of order' or McGowan's reference to Lynch's apparent 'obscurantist proclivities' (51) are fundamentally problematised. The scenes in *Mulholland Drive* are not 'out of

order' if they are not necessarily drawn from a coherent wider fabula, and Lynch is obscuring nothing if that which he *would* be obscuring does not exist.

Even when Lynch's films *do* seem to elucidate consistent diegeses, I would contend that one is often still thwarted if one interrogates this notion and attempts to locate their action within stable realities. In reference to *Blue Velvet*, for instance, Chion enumerates ways in which its plot proves to be far from watertight on logical inspection: elements such as Frank's (Dennis Hopper) lack of a 'clear, rational motive for kidnapping [Isabella Rossellini's character] Dorothy's husband and child'; the way in which 'the confusion surrounding the third man's identity leads nowhere'; and the manner in which 'lapses in the characters' behaviour add yet another layer of strangeness' (85). To this list I would also add the inexplicable nature of a lot of crucial plot points, such as a severed ear turning up in a field, the fact that anyone makes a connection between this body part and the plight of Dorothy when she is so emphatic about not telling the police anything, and the fact that Jeffrey Beamont (Kyle MacLachlan) asks very specifically to see Detective Williams (George Dickerson), who then turns out to know him only very vaguely. Chion also problematises *Blue Velvet's* scenes' chronology when he writes that Frank and Dorothy's act of 'lovemaking' is 'outside time,' stating that 'there is no difference between the continuous scene at which Jeffrey is present and the shots in which he remembers it'(88).

Of all Lynch's films, however, *INLAND EMPIRE* makes its diegetic instability most aggressively evident from the very beginning. The second scene of *INLAND EMPIRE* features a character credited only as The Lost Girl (Karolina Gruszka) sitting on a bed in a hotel room, naked except for a bed-sheet which she clings to her chest. She silently cries in front of a television screen, and shot-reverse-shots provide us with images from this screen: first, static interference; then, a shot of three

people dressed as anthropomorphic bunnies in a sitcom-esque living room set; then, an accelerated shot of Visitor #1 (Grace Zabriskie) walking up a pathway. Eventually, the television returns to static, which fades into the shot of the anthropomorphic bunnies. Thus begins a scene featuring these bunnies, voiced by Laura Harring, Naomi Watts and Scott Coffey. The bunnies exchange banalities – 'What time is it?', 'There have been no calls today', 'I do not think it will be much longer now' – occasionally punctuated with canned laughter at seemingly arbitrary intervals.

During this scene, while the shots of the bunnies do not seem to be conveyed through a television screen, they remain intercut with close-ups of The Lost Girl with tears rolling down her cheeks. This would seem to imply that the metalanguage's reality – as opposed to the framed tangential realities of flashbacks, fantasies, or, indeed, events on a television screen – is The Lost Girl in her hotel room, and yet at the end of this scene we are not returned to The Lost Girl in her hotel room, as we might expect. Instead, the male bunny walks out of the room and into a sizeable and incredibly baroque drawing room in darkness. The room is then gradually illuminated, the bunny disappears, and a scene set in this room begins. The Lost Girl does not reappear until the film's second third.

Subsequently, however, the image of Visitor #1 walking up a pathway recurs. It is this time seemingly not mediated as a television image being watched by The Lost Girl, yet - since we were never returned to the apparent metalanguage's reality of the room in which The Lost Girl watches television – the question of whether we are to infer that the metalanguage's reality is still this room, and we are watching Visitor #1 walk up the pathway through the eyes of The Lost Girl, remains. Later in the film, we again receive this impression, as shots which initially formally appear to be unproblematically conveyed through a metalanguage are shown on her television screen.

Yet notions that *INLAND EMPIRE*'s action is consistently framed as imagery on The Lost Girl's television screen collapse at the film's end, when Laura Dern's character – who has hitherto been present in scenes which, in such a formulation, appear on the television screen – enters The Lost Girl's hotel room, thereby conflating the supposed reality of the metalanguage with the apparently subordinate reality of the screen's action – a conflation reinforced by fact that the image of Dern's character encountering The Lost Girl at this point is presented to us both as conveyed by a metalanguage and as an image on the room's television screen. Besides, even prior to this denouement, Gruszka appears throughout the film in numerous incarnations – for instance as a nun and as a woman involved in some kind of abusive relationship with a mysterious figure credited only as the Phantom (Krzysztof Majchrzak) - undermining the concept that her character is somehow an observer apart from the film's action.

Such instability of the fictional identity of characters is integral to the undermining of the notion that a given film by Lynch articulates - to again quote Barthes's *Writing Degree Zero* - 'an autarkic world which elaborates its own dimensions and limits, and organises within these...its population' (35), because the characters cannot be seen as figures in a stable reality if their identities are constantly in flux. It is also a crucial facet in terms of the manner in which his work might be said to denaturalise the 'conventions of embodiment, violence, sex, desire and gender' and move 'these elements away from traditional terrains of meaning...provocatively refiguring gender and sexuality' (Braziel, 108). If one cannot be sure of a character's identity, one's ability to apprehend the film with essentialist categories is retarded; gender (and other) norms cannot be pre-discursive givens if identities are so constantly in flux. This allows 'for no unambiguous correspondences between visual signifiers and culturally determined signifieds' (Jerslev, 157). Despite their form

not conveying scenes cumulative to the elucidation of a fabula occurring within a stable diegesis. That the latter may be the case is cemented in the second scene I will discuss, which occurs roughly three minutes later.

In this scene, characters performed by Dern and Theroux are in a bed. Illuminated with blue light, they appear to be having sex, and converse in tight close-up shot/reverse-shots. At first, they express their pleasure at the experience, but midway through, the scene takes a more sinister turn as a P.O.V. shot from outside the doorway announces the presence of Piotrek. As Piotrek watches, Dern's character begins to talk cryptically about 'a thing that happened yesterday, but I know it's tomorrow.' She refers to a 'scene' she filmed a day before, and as she speaks, Theroux's character looks confused, and tells Dern's character that she's not making any sense, repeatedly addressing her as Sue. Dern's character then, addressing Theroux's character as Devon, frantically says 'It's me, Nikki!' The face of Theroux's character then becomes maniacally pained and the scene ends with a sped-up handheld shot retreating from the doorway and down a corridor, upon the walls of which shadows dance.

Up to the point of the P.O.V. shot, the actors do not refer to each other by name, and so the scene may well take place within 'On High in Blue Tomorrows'. We know, after all, that the characters performed by Devon and Sue are engaged in an extra-marital affair. The P.O.V. shot, however, reveals that, in this case, neither Kingsley Stewart nor his camera are present, and the notion that the scene takes place in the characters' 'real life' is ostensibly confirmed by Dern's reference to the 'scene' filmed a day before. Yet Theroux's reaction implies that he is performing as Billy Side, which contradicts that which the metalanguage seems to tell us. In this scene, however, one does not get the impression that the metalanguage provides a 'final say', as one does in the other scene. If one is attempting to hold onto diegetic logic at this point, one may assert that it is clear here that Devon

is confusing reality and fiction, as Nikki appeared to be in the prior scene. Yet there is no diegetic basis for either of them to do so. The other scene ends with a close-up of the camera, as if to reassure the audience that, despite Nikki's behaviour making no sense, the metalanguage should still be taken to convey an unquestionable reality. This scene, though, ends in a manner which is deeply unsettling and does not purport to provide such reassurances.

Even when their identities do not seem to contradict the authority of his films' apparent metalanguage, the behaviour of Lynch's characters often impedes the audience's ability to position themselves as comfortably omniscient because, while the characters' behaviour may not amount to the dissolution of their hitherto established identities, it is so incongruous as to make little sense in terms of that which has come before. Steven Jay Schneider discusses such unmotivated behaviour of characters within Lynch's films. Employing the example of *Eraserhead*, Schneider takes numerous instances from the scene in which Henry Spencer (Jack Nance), the protagonist of the film, visits the family of Mary X (Charlotte Stewart), his girlfriend, for dinner. Examples identified by Schneider include the 'succession of tics and spasms on Mary's part' and when 'Mary's mother falls victim to a quasi-epileptic fit of her own...kissing her son-to-be-son-in-law's neck' (Schneider, 8). He asserts that 'such episodes of bizarre, irrational, behaviour can be found in almost all of Lynch's films, including even the so-called *The Straight Story* (1999)' (8), but I would argue that the behaviour need not even be so overtly strange in order to destabilise the spectator.

As I acknowledge above, *Mulholland Drive* is another film which renders its characters' identities ambiguous. This is most prominent in the final third, when actors reappear with new fictional names and personalities. There is, however, an earlier scene which does not explicitly throw the film's metalanguage into doubt (nothing happens which is necessarily 'impossible' in

reference to that which has hitherto been established), but which – through a characters' behaviour – forces us to question certain fundamental assumptions usually taken as read when watching classic realist film. The scene occurs when Betty Elm (Naomi Watts) attends an audition and performs with Woody Katz (Chad Everett). Up until this point in the film, Watts's performance of Betty has been perennially enthusiastic. This is typified by the first scene in which she appears. Awestruck on an escalator in LAX, she stares at off-screen space wide-eyed, and delicately shakes her head as if in incredulity. This display of innocence continues consistently throughout the film, up until the point of the audition. During the audition, though, Watts begins performing the character in a completely different way. Standing extremely close to Everett, she delivers the lines in a heavy whisper, often almost kissing him, and, as Martha P. Nochimson writes in her essay *All I Need is the Girl*, cultivating a 'dangerously erotic mood' (172).

Chion writes that, at this point, 'Betty seems to be acting "for real"' (218) and Rodley comments that Betty seems to only become '"real" when she plays someone else' (293), but one might also say that Watts is acting 'for real' for the first time in the film. While her performance as Betty could hitherto feasibly be criticised as a one-dimensional pastiche of a hopeful starlet, her performance here is utterly compelling in a manner conventionally praised as believable. As George Toles writes:

> We find ourselves capitulating (like moviegoers in childhood) to everything we see and hear immediately after receiving elaborate assurance, within the hideously false context of an ill-managed Hollywood audition, that there is no possible basis for belief of any kind. (2-3)

One could simply draw from this scene the revelation that, despite Betty's seemingly naïve persona, she is actually a very

talented actress, or one might allow the scene to raise elementary questions concerning the film's notional reality: what does it mean for the manner in which we apprehend the film if we are intuitively more prepared to accept as real something which the film's metalanguage is telling us is artifice than we are to accept as real something which the film's metalanguage is telling us is real?

Above, I appropriate a quote from Barthes's *Writing Degree Zero* in expressing the manner in which this instability of characters' identities undermines the notion that Lynch's films articulate that which Barthes refers to as 'an autarkic world which elaborates its own dimensions and limits, and organises within these...its population.' From that quote, I omit the words 'its own Time, its own Space', due to their lack of relevance to the matter at hand, but now I turn to the way in which the indeterminacy of these elements within Lynch's films – the 'fluctuating and profoundly ambiguous' nature of his timespaces (Jerslev, 151-152) – works to destabilise the spectator.

Indeterminacy of timespace is common in experimental film, often fuelled by the impetus of, as Stephen Heath writes in reference to the work of Dziga Vertov, challenging the dominant discourse's articulation of reality with 'constructions of dissociations in time and space that would produce the contradictions of the alignment of camera-eye and human-eye in order to displace the subject-eye of the social-historical individual into an operative – transforming – relation to reality' (Heath, 33). As I establish above, Lynch is by no means a political firebrand in the Vertov mould, and yet much of his oeuvre might work to question a pre-given vision of reality in such a manner.

One locale in Lynch's work which is definitively indeterminate in terms of its timespace is the Black Lodge in *Twin Peaks* (1989-1990) and *Twin Peaks: Fire Walk With Me* (1992), a place which is made extremely familiar to the viewership of *Twin Peaks* through its recurrence in the series, but which is also profoundly

inaccessible and mysterious in terms of any diegetic logistics. This is best explored through a description of a scene within the Black Lodge in the Lynch-directed series finale of *Twin Peaks*, 'Beyond Life and Death', in which Special Agent Dale Cooper (Kyle MacLachlan) physically enters the space.

The Black Lodge apparently has no walls, instead its rooms are divided with red curtains, and its floor is patterned with black and white zig-zags. After a scene in which Cooper sits in a chair beside the Man From Another Place (Michael J. Anderson) and characters such as the ghost of Laura Palmer (Sheryl Lee), the Giant (Carel Struycken) and the Elderly Bellhop (Hank Worden) appear and disappear within the space without apparently entering or leaving, Cooper leaves this room, proceeds down the corridor and seemingly ventures into another room. This new room, however, is identical to the room which he just left, only without the Man From Another Place. He walks back through the curtain and down the corridor into the room in which he was initially, to indeed find the same room.

The Man From Another Place tells Cooper that he has gone the 'wrong way', and so Cooper leaves the room and enters the opposite room in the exact same place as he did before, only now he enters an identical room from another direction. Then, after a reverse shot of Cooper, The Man From Another Place appears, laughing crazily. He says 'Another Friend', and disappears behind a chair as Maddy Palmer (Sheryl Lee), emerges from the very part of the curtain through which Cooper apparently entered this room the first time. She says, 'Watch out for my cousin.' Cooper leaves and walks back down the corridor and into the other room, only to find it completely empty.

Cooper then looks down, and in a reverse shot we see The Man From Another Place. In terms of scale, the zig-zags on the floor are the same size as they would be if, proportionally, the Man From Another Place was only as small as he normally is, yet the sequencing of the shot – deployed after Cooper looks down

offscreen, seemingly scrutinising something extremely small – creates the illusion that he is miniscule. He viciously says 'Doppelganger', and a furiously screaming Laura Palmer appears, writhing on a sofa which was not in the room previously. She lunges at Cooper and he flees and nonchalantly enters the room opposite. Once inside this room, however, he discovers he is wounded and has left a trail of blood behind him.

Cooper then walks back through the curtain and into the corridor, and a classical statue which has hitherto been present at the end of the corridor is now no longer there. He then walks back into the other room and sees the dead bodies of himself and Annie Blackburn (Heather Graham) lying on the floor. He calls out Annie's name and she becomes reanimated, looking inquisitively around the room. The lighting then begins to strobe and a P.O.V. shot from Cooper's perspective reveals that the bodies of Annie and Cooper have disappeared. Cooper then leaves the room and proceeds down the corridor into the other room again to find an unharmed Annie. His wound has now also disappeared. Subsequently, there follows scenes of cryptic dialogue and drama featuring Windom Earle (Kenneth Welsh), the demonic BOB (Frank Silva) and an evil doppelganger of Cooper. These scenes are conveyed in a similarly ambiguous way, but I think all of the above more than suffices to illustrate the profound indeterminacy of the Black Lodge's timespace.

Despite all this, the Black Lodge *is* framed as a supernatural space and thereby - while Cooper's traversal of it certainly disorients the spectator - it does not necessarily leave the spectator destabilised on a fundamental level, in that it could be seen as justified in relation to the metalanguage's reality. Far more profound spectatorial destabilisation is cultivated, however, when the timespace of locales which have hitherto been established as coherent and quotidian in terms of the film's diegeses are problematised in such a manner. This might be exemplified with a scene from the first third of *Lost Highway*.

Up to this point in the film, an ostensibly stable diegesis has been established. Bill Pullman portrays Fred Madison, a jazz saxophonist living in L.A. His wife, Renee Madison (Patricia Arquette), is icy and emotionless towards him. The couple start receiving videotapes which contain films of their house, first shot from outside, and subsequently from inside. Despite a few bizarre moments featuring The Mystery Man (Robert Blake), the metalanguage's claim to an ultimate truth is intact, and it is seemingly capable of discussing the relation to truth of the characters' articulations of reality, a concept exemplified by Warren Buckland's claim that a sequence from this first third in which Fred phones his house and we see shots of unanswered telephones introduces 'a discrepancy between Renee's words and her actions', because she has said in a prior scene that she would stay at home that night (45).

The scene which problematises this coherence begins with a shot of Fred standing in a bedroom looking disturbed. He walks over to a doorway and we cut to a shot of Renee, who appears to be in the process of removing her makeup with cotton wool while looking into a large mirror. A man's figure, which we are led to assume is Fred's despite the figure's face not being visible, appears in the far left corner of the frame, and Renee steelily acknowledges the figure's reflection. We then cut to a shot of Fred in a doorway. We are led to read this as the doorway in which the male figure in the reflection is standing, although the lighting and the colouration of the walls almost seem like that of another room to that in which Renee sits. Fred then commences to move out the doorway; we cut back to Renee, the male figure in the far left of the screen moves out of shot and Renee continues rubbing the ball of cotton wool on her face. We then cut to a shot of Fred opening the door of a cupboard which is almost pitch black inside, and beginning to take his jacket off. We cut to Renee removing her makeup. We cut to Fred closing the cupboard. Upon shutting the cupboard door there is a sound far

louder than one would assume such a cupboard door to make when closed (more akin to a cannonball), and an ominous drone begins on the film's score.

Fred then turns to stare at off-screen space with an expression of dread inordinate to his apparent diegetic surroundings. In a wider shot, he begins to walk over to this off-screen space and, as the camera follows him, it is revealed that he is staring into an area of darkness which is unclearly defined: we cannot be sure whether it is a corner or a corridor. We then cut to Renee, who disposes of the cotton wool before returning to Fred, who walks into the darkness and is seemingly engulfed by nothingness. The film then cuts back to Renee, who is washing her face in the basin. She raises her head to look off-screen, as if perturbed by the insidious drones on the score, and the camera tilts up with her. We then cut to a shot which is entirely spatially indeterminate and cannot be mitigated with the rest of the spaces already so obliquely mapped out in the scene whatsoever: Fred appears to be looking into off-screen space. He walks forward, and it is revealed that we have been watching his reflection, as Fred's head emerges in the left corner of the screen, looking into a mirror.

We then cut to a shot of the bedroom, which is now empty. Renee walks through a doorway and the camera follows her as she approaches the same indefinite space which we saw Fred walk into a few shots before. She calls out 'Fred!' and 'Where are you?' before walking out of shot. We then cut to a shot of a living room, along the walls of which the shadows of two figures walk. Then, we cut back to a shot of the indeterminate space, from which Fred emerges. He walks forwards until his face engulfs the screen in shadow.

Yet it is not only through this form of utter disorientation that rational diegetic timespace is confused in Lynch's work. His oeuvre also contains numerous instances of characters moving between or simultaneously existing in seemingly disparate spatial and temporal points in a manner which is conveyed as a

logical progression, but which makes no sense as according to any diegetic logic. Above, I acknowledge that indeterminacy of timespace is a common trope of experimental film, and this technique of characters existing in multiple places simultaneously and moving between disparate spaces as if they were proximate has definitive precedents in experimental filmmaking and theory. Maya Deren, for instance, writes very specifically about it in a 1960 essay on film form. She enumerates techniques through which the filmmaker might create 'a relationship between separate times, places, and persons...accomplished by a meaningful manipulation of the sequence of film images', one of which is an actor beginning 'a gesture in one setting [with the] shot being immediately followed by the hand entering another setting altogether to complete the gesture there' (68). This technique is evident in Deren's own filmmaking, most notably *At Land* (1944), a film in which 'spacial elisions or temporal ellipses' are deployed 'as formal or stylistic devices' (Sitney, 22). The first five minutes of the film exemplify this: Deren's character wakes up on a beach, climbs a tree, and pulls herself up onto a table, around which men and women smoke cigars. She then crawls across the table and eventually through some foliage onto a waterfall.

A similar dynamic is often at work in *INLAND EMPIRE*. For the majority of the film, Dern's character appears in various apparently unrelated locales, and she often appears to travel between these spaces as if they were contiguous. The first major instance of this occurs when Dern's character enters the door of what appears to be a façade of a building referred to as Smithy's House. Upon walking through this façade, however, she finds herself in an actual room. She subsequently exits this room, apparently through the very door she entered, into an expansive courtyard. The manner in which her travelling between these spaces is conveyed is not unconventional in terms of the classic realist film, and an identical shot sequence could be employed by

a metalanguage to convey action which poses no challenge to spectatorial omniscience if the spaces were not so disparate, or the film did not lack some coherent diegetic reason as to why it would be possible for Dern's character to travel between them with ease.

The affinity between the temporal and spatial ambiguity in Lynch's and Deren's filmmaking - and that Lynch establishes this ambiguity with of the classic realist film's visual rhetoric - is acknowledged by Nicholas Rombes. Rombes asserts that, while Deren's work was made in opposition to the commercial cinema, 'Lynch's films nest experimentalism in...traditional Hollywood narrative conventions' (72). He explores this in reference to *Twin Peaks: Fire Walk with Me*, which he writes 'violently marries the logic of the classical Hollywood style and non-representational cinema' (Rombes, 72). To exemplify this, he chooses a scene in which Laura Palmer (Sheryl Lee) stands in her doorway and sees the same moment photographed upon her wall, as if it had happened in the past (a very similar scene occurs in *INLAND EMPIRE*, with a cinema screen instead of a photo). In terms of any diegetic logic, Rombes acknowledges that the scene is impossible, and observes its similarities to Deren's work. He writes:

> The scene is strikingly reminiscent of Deren's similar experiments with doubling and spatial dislocation, especially in the silent *At Land* (1944), where, in the opening sequences, Deren emerges from the ocean (its waves rolling backwards in reverse motion), climbs an enormous piece of driftwood, and finds herself crawling simultaneously through the underbrush (exterior) and an enormous banquet table, around which people sit oblivious to her presence. Like Laura Palmer, she crosses and exists in multiple places simultaneously, and gazes upon herself as she does so. (Rombes 72)

One might also point towards a sequence within Deren's work

Meshes of the Afternoon (1943). In *Meshes of the Afternoon*, there is a scene in which Deren's character is descending a staircase, and gravity apparently reverses, leaving her seemingly floating, clinging to steps. She finally reaches an archway and holds on to the top, as if being forced back by winds. As she does so, she looks down into the room below her, and in a panning eyeline match shot we see Deren, wearing the same dress, asleep in a chair. Beside her there is a turntable, and as if to cement the concept that these two figures exist in the same space, the figure in the doorway reaches down and lifts the turntable's stylus, before emerging in the same shot as the sleeping character. She then looks out the window, and in a reverse-shot we see a mysterious figure in a gown - familiar from earlier in the film - walking up a pathway, followed in a run by a character performed by Deren. Then, lest the spectator assumes that there was in fact a diegetic temporal leap forward between the shot of Deren looking through the window and Deren running along the pathway, we cut back to Deren watching through the window, watching herself while apparently in a room with herself asleep in a chair.

While Rombes chooses the scene from *Twin Peaks: Fire Walk with Me* as exemplary of a character's activity rupturing coherent diegetic timespace through seemingly existing in two places at once, incredibly pertinent instances can also be found in *INLAND EMPIRE* and *Lost Highway*. In *INLAND EMPIRE*, one good example occurs roughly two hours into the film. Dern's character stands on Sunset Boulevard faced with a group of girls who reappear throughout the film, and at this point seem to be prostitutes. In this scene, the fictional identity of Dern's character is so indistinct as to be impossible to determine, and this is reflected in the manner in which she switches between registers in her performance. She plaintively says 'I'm a whore…where am I?' before shouting 'I'm afraid!' with grossly performative intonation. She then begins laughing uncontrollably, a fit shared

by the group of girls, before her attention is caught by something off-screen. In an eyeline match shot, we see the other side of the road, down which a character performed by Dern walks dejectedly, her face beaten and a screwdriver in her hand. *Her* attention is then attracted over the road, and in an eyeline match shot we see the character performed by Dern whose eyeline we followed in order to see the character performed by Dern whose eyeline we *just* followed (referred to from now as Dern A and Dern B respectively to avoid confusion). We then cut back to Dern B, who looks aghast, and back to Dern A, who leans forwards, her face in a mocking grimace. We cut back to Dern B, who stares in disbelief, and back again to a disarmingly extreme closeup of Dern A, who looks utterly maniacal. None of the visual rhetoric employed in this scene is alien to the classic realist film, but its deployment is profoundly disorienting.

Another example from *INLAND EMPIRE* comprises two scenes, one which occurs within the first half hour of the film, and another which occurs between two scenes discussed above: just subsequent to the sex scene and just before Dern's character enters the Smithy's House facade. In the first scene, Nikki and Devon are reading through their lines with Kingsley and his assistant Freddy (Harry Dean Stanton) in a studio lot and hear a noise from the unfinished set behind them. Devon goes to investigate in a sequence full of tension which, again, derives its suspense primarily from its music. He follows footsteps to the Smithy's House façade and tries to open the door, to no avail. He then looks through the façade's windows and behind the façade, but no-one is there. He returns to inform Kingsley and Nikki that whoever was there 'disappeared where it's real hard to disappear.' Two shots within this scene abruptly cut to black. The first is a zoom-in from wide-angle shot of Kingsley, Nikki and Freddy as they watch Devon going to see who is on the set, which cuts to black before the zoom appears to settle. The second is a shot of Devon peering through the façade from the other side of

the façade's window, which is interrupted midway by black replacing a number of its frames.

In the second scene, Dern's character (at this point, after the sex scene, it is unclear – or irrelevant, or only relevant insofar as it is unclear - who she is performing as) is in an alleyway and ventures into an open metal door. Subsequently, we cut to an out-of-focus shot of Dern's character approaching us, increasingly coming into focus as she gets nearer. When the shot has become a close-up, it is clear that she is looking into off-screen space. In an eyeline match, we see what appears to be the read-through from the scene discussed above. Then, we again see the characters notice the sound of the intruder, now apparently revealed to be Dern's character. The scene continues, Devon proceeds to venture into the unfinished set to investigate, and then there is a shot with the actors in identical positions to the earlier interrupted zoom shot, only without Nikki. Ominous drones then emerge on the score, and a sequence of shots portray Devon's pursuit of Dern's character. As described above, Dern's character then enters the façade's door and walks into an actual room. At this point, we again see Devon peering in through the window from the other side, although we can now identify this shot as a P.O.V. belonging to Dern's character, who – despite the implication that Theroux is at this point performing as Devon – repeatedly screams 'Billy!'

A similar two scenes implying that a character is in multiple times and places at once bracket *Lost Highway*. In the first scene of *Lost Highway* subsequent to its credits sequence, Fred wakes up and hears his intercom buzzer. He presses the 'listen' button and a voice says 'Dick Laurent is dead.' As he walks towards the window to see who the voice belongs to, we hear the off-screen sound of tyres screeching and a police siren, but when he reaches the window no-one is outside. In the film's closing sequence, subsequent to shooting a character portrayed by Robert Loggia who throughout the film is referred to as both Mr. Eddy and Dick

Laurent, Fred pulls up to his house and presses the intercom, before saying 'Dick Laurent is dead' into it. Two detectives then appear, and Fred leaps back into his car. A chase ensues.

Lost Highway, then, begins with Fred hearing a voice through his intercom informing him that 'Dick Laurent is dead', and ends with a scene which gives the impression that it was his voice, and the sounds that Fred heard were the sounds of the police chasing him. These scenes provide *Lost Highway* with a circularity which does not have recourse to a coherent diegesis – as Rombes writes of the revelation, 'this information does not really explain anything. Solving the mystery has not solved the mystery, after all' (74) - but which lends the film a sense of conclusiveness in terms of its structure, and it is to the structure of Lynch's films – holistically and on the level of individual scenes – which I turn in the next chapter.

Simply a Kind of Flow

In the preceding chapter, I argue that, while they primarily employ the visual rhetoric of classic realism, many of Lynch's films do not allow their audience to take a position of omniscience towards their action because – due to the transiency of their characters' fictional identities and the indeterminacy of their timespaces – they fail to cultivate the stable diegeses which are necessarily established if a subject is to have such a relationship towards that which films portray. Because of this, I posit that they might be said to have syuzhets without fabulas: they are composed of scenes which ostensibly elucidate events occurring in fictional worlds, but thwart attempts to consolidate these diegeses cohesively.

David Roche makes a similar in point in relation to *Mulholland Drive*. He writes of how the film frustrates 'the spectator's need for a rational diegesis by playing on the spectator's mistake that narration is synonymous with diegesis', concluding that 'in *Mulholland Drive*, narration prevails over diegesis.' As Roche surmises, when watching *Mulholland Drive*, 'the spectator has no other choice but to [let] narration carry him along' and experience each moment as it comes, not expecting the scenes to be cumulative to the articulation of a coherent diegesis.

Roche's use of the word narrative is notable because, while other forms of filmmaking which eschew the construction of rational filmworlds are often referred to as 'non-narrative', if we accept the word narrative as defined, as it is the *Oxford Dictionary of English*, as an 'account of connected events' (1169), it would be incorrect to refer to Lynch's work as 'non-narrative'. My textual analysis in the last chapter makes clear that the events which comprise the syuzhets of Lynch's films are connected, because the apparent irrationality of some of these connections is one of

the facets which might restrict the spectator from a position of comfortable omniscience. My textual analysis in the last chapter also makes clear that this perceived irrationality is due to these scenes employing the tropes of classic realist visual rhetoric, for example the shot sequence in *INLAND EMPIRE* which conveys Dern's character entering the façade of Smithy's House and ending up in an actual room. In this chapter, I explore the manner in which the syuzhets of many of Lynch's films are structured as causal chains – as narratives - without the dubious implications of selective linearity delineated above, and the manner in which their individual scenes are structured in a way which employs the visual rhetoric of classic realism to ambiguous ends.

Chion writes of how, 'in Lynch's view, his interest in narration...separates him from surrealism' (24), and this is evident if one compares Lynch's work with that most heavily cited of surrealist films produced contemporary to the movement itself, *Un Chien Andalou*. Salvador Dali and Luis Bunuel assert that, in preparation for the film, they 'accepted only those representations as valid which, though they moved them profoundly, had no possible explanation' (qtd. in Sitney, 4). When they had settled upon these 'representations,' however, they proceeded to structure them with only the loosest of causality. Thus, the film cuts from a man (Bunuel) appearing to slice open a human eye, to the image of a night cloud passing across the full moon; from a man (Pierre Batcheff) dragging two grand pianos, two dead donkeys and two priests, to him throwing off this heavy load getting his hand trapped in a door, from which emerges a swarm of ants; from a woman's (Simone Mareuil) armpit hair leaving her armpit and replacing the man's mouth, to her strutting out a door onto a beach.

From that which he has confessed of his creative process, Lynch appears to work from a similar basis for his films which are not adaptations, insofar as he does not begin with a plot. Instead, Lynch's films often find their genesis in ideas for seventy

scenes written on index cards, which are subsequently connected to create the film's narrative (Wilson, 7). Thereby, while *Un Chien Andalou* was entirely based upon spontaneous imagery from its creators' subconscious minds, 'Lynch's films grow from a negotiation between unexpected images arising from the subconscious and disciplined organisation of the conscious mind' (Wilson, 7).

This 'disciplined organisation' often results in syuzhets which connect these 'unexpected images' in chains which are more distinctly causal than *Un Chien Andalou's* disjointedly anarchical syuzhet. This ostensibly aligns Lynch's work with the archetypal classic realist film, because - as I explore above - the selective causality of narratives is integral to the mode, and the crux of its analogousness with the dominant discourse's historiography. However, in the case of Lynch's films, the audiovisual imagery of one given moment is not primarily of significance insofar as it conveys information which one might relate to the audiovisual imagery of another moment, and all of these moments cannot necessarily be evaluated as according to the concluding moment. This is why I would argue that the causality of Lynch's films has less in common with the causality of the archetypal classic realist film, and more in common with the 'kind of flow' (123) which Barthes argues is manifest in the narrative of George Bataille's novel *The Story of the Eye*. As Barthes writes:

if we are in a park at night it is in order that the moon can emerge from the clouds to shine on the wet stain in the middle of Marcelle's sheet as it flaps from the window; if we visit Madrid it is in order that there shall be a bullfight, with the offering of the bull's raw balls and the putting out of Granero's eye; if we go to Seville it is in order that the sky shall exude...yellowish, liquid, luminosity. (123)

Similarly, the narratives of Lynch's films often seem to operate in such a manner: If we are in Club Silencio, it is so we might

witness an intensely affecting Spanish rendition of Roy Orbison's 'Crying' by Rebekeh Del Rio; if we are in a desert outside a cabin, it is so that cabin might burst into flames and burn solitarily in the dust. To employ a formulation from Theodor W. Adorno's *Aesthetic Theory*, one might say that, in the case of much of Lynch's oeuvre, 'the whole in truth exists only for the sake of its parts' (187).

Schneider explicitly discusses *Eraserhead* in such terms when writing of 'the primacy of the audiovisual image...*despite* the film's recognisable narrative elements' (6). He concludes that 'it is the film's storyline which gets determined...by its images' (Schneider, 7), and this certainly seems to be the case. The film begins with a shot of a semi-illuminated small rocky planet, over which Henry's face is translucently superimposed as hovering, all set to audio akin to the sounds recorded by NASA on Jupiter; and ends with Henry bathed in white light, ecstatic in the embrace of the enigmatic Lady in the Radiator (Laurel Near), while a hellish choral soundtrack builds to a crescendo which is never reached. Between these two audiovisual images, the film displays miniature roast chickens which spew indistinct dark goo from their rectums; two adulterous lovers descending through bed sheets into a fiery crater; Henry's decapitated head falling from the sky and awakening a hobo upon impact; and bizarre infanticide which results in an eruption of foam from the victim's guts.

While all of these audiovisual images are connected in a causal narrative, at no point during *Eraserhead* does one receive the impression that the action is taking place in a comprehensible world towards which one might take a position of omniscience. No reasoning is elaborated for the desolate, seemingly post-apocalyptic wasteland which the characters inhabit, and none of the characters are provided with sophisticated histories. Indeed, aside from the dinner scene – in which Henry complains to Mary that she never comes round anymore, and informs her parents that he used to work as a printer – throughout *Eraserhead* there is

no reference to the film's world having pre-existed the film. The film's narrative, then, does not so much convey a fabula occurring in a coherent diegesis as act as a chain to link its striking audiovisual images, and so conceiving of the scenes as primarily of significance in relation to one another and, ultimately, in relation to the film's conclusion seems misguided.

That Lynch's films' scenes are never stringently cumulative to their conclusions is true even of *The Straight Story*, his film which most unproblematically falls into the category of classic realist. The film tells the story of Alvin Straight (Richard Farnsworth), an elderly man who travels from Iowa to Wisconsin on a lawnmower to visit his brother Lyle (Harry Dean Stanton). In *The Straight Story*, explicable connections between striking audio-visual images which justify these audiovisual images' presence and elaborate the film's wider diegesis are certainly more prevalent than is common in Lynch's work, for instance a beauti-fully ambiguous scene in which Rose Straight (Sissy Spacek) stares woefully out her window at a child chasing a ball is later revealed to be of significance because the local county deemed her unfit to care for her own children. However, once Alvin's quest begins in earnest, the film's episodic nature is thus that recourse to a prior scene is not necessary for appreciation of a given scene.

Although all this is by no means to imply that the order of scenes in Lynch's films is in any way arbitrary. As I acknowledge above, Lynch asserts that in his work he sequences scenes in a manner which 'gets the whole to feel correct' and, indeed, Lynch refuses to include chapter menus on the DVD editions of his films because he does not wish for their scenes to be watched in any other order. Yet - as I discuss above - the lack of stable diegeses from which his films' scenes are drawn means that this order is not necessarily an order with recourse to a coherent fabula. Instead, when asked about the manner in which he orders scenes into narratives, Lynch makes an analogy which has

been used many times by experimental filmmakers wishing to discuss the structures of their films in lieu of the function of elucidating a coherent fabula, that of music.[2] As Lynch explains to Rodley:

> Every ingredient has got to be right. Like in a symphony. You're just building and building. You're getting somewhere, but the pay-off is only going to happen because of what's gone before. You can't just have those chords come out of nothing. All the stuff that goes before it is leading to those things hitting in a certain way. (227)

Theorists, also, have turned to music as an analogue in their discussion of Lynch's work. For instance, Chion makes a comparison between the flamboyance of *Wild at Heart's* (1990) credit sequence and the manner in which 'a tonality is affirmed at the beginning of a symphony' (126).

As Adorno writes, music seems to say something, but that which is said 'cannot be detached from the music', because music 'creates no semiotic system' (qtd. in Jarvis, 127-128). Thereby - as Simon Jarvis surmises - 'no semantic 'content' can be paraphrased from a musical work', despite its undeniable value as 'more than just sounds' (128). When one receives a sense of aesthetic rightness from music, it is not consciously in accordance with prefigured meaning, it is a process of perception and sensitivity rather than fixed ideas. I would thereby argue that music inherently has the capacity to engender the mode of reception which I above delineate as inimical to the mindset of the dominant discourse, and aligning the composition of Lynch's films with the composition of music implies that his films might also be received in the manner akin to the way in which one receives music.

While the scenes of Lynch's films are often connected in causal chains, then, their sequencing seems not so much cumulative to

an endpoint from which one might survey and evaluate the scenes as it is - as is the case with the organisation of sounds within musical compositions - 'determined by rhythm and dramatic effect', and it is with these words that Sitney describes Jack Smith's *Flaming Creatures* (1963), an experimental film which one can certainly speak of in terms of its affinity with music - as Sitney writes, 'the style of photography changes with the scenes, orchestrating them as if they were movements of a musical work' (354) - but which employs visual rhetoric approximating that of classic realism. As in the work of Lynch, *Flaming Creatures* appropriates these classic realist tropes in a manner unconcerned with recounting a fabula and conferring omniscience on the spectator.

Like Lynch, Smith never displayed particular political engagement. However, he 'insisted that art be an antidote to the spiritually and aesthetically deadening effects of American capitalist society', and so the aesthetic aplomb of his films mark them out as indirect critiques of the dominant discourse (Rinder 139). The power of a film such as *Flaming Creatures*, Susan Sontag argues, is 'not in the knowing about...what one sees...but in the directness...of the images themselves.' (229) The film, writes Sitney, 'deliberately manifests what [Jack Smith] finds implicated in Maria Montez's and Von Sternberg's films' - namely sumptuous visual texture and rich ambiguity of meaning - 'without the interference of a plot', and it does so by retaining 'the structure of the scene' (353-54). Thereby, *Flaming Creatures* certainly owes much to the classic realist mode, but it owes much to it insofar as it follows many of the mode's 'rules', without the definite signified for which this signification was developed. The manner in which works by the two filmmakers appropriate elements of the classic realist film can be well demonstrated with a sequence from *Flaming Creatures* and a sequence from *Mulholland Drive*, both of which compositionally intimate parallel action..

The sequence from *Flaming Creatures* occurs after the opening

credits and is comprised of three scenes. The first features inter-actions between a transvestite in a white dress and a woman wearing a black nightgown. In shots which isolate the figures, the woman wiggles her hips to the soundtrack's Spanish music and the transvestite waves to her. They then meet together in a shot and kiss. The film then cuts to a sequence which shows a group of people putting on lipstick in panning shots set to a commercial for 'a new heart-shaped lipstick that stays on and on' on the soundtrack. As this scene continues, we languidly float over a mass of nude and semi-nude people all applying lipstick, before returning to the transvestite and the woman. The transvestite then begins chasing the woman until eventually the transvestite catches the woman and hurls her to the ground.

The sequence in *Mulholland Drive* begins with a scene in which Rita (Laura Harring) - who we have previously seen escaping from a car accident - stumbles into a house. At the end of this scene, Rita seemingly falls asleep and the film cuts to a scene set in a Winkies diner which features two characters, Dan (Patrick Fischler) and Herb (Michael Cooke), who – with the exception of Dan in one shot near the end – never appear again within the film. The scene proceeds thusly: Dan and Herb sit opposite each other. In shot-reverse-shots, Dan tells Herb that he has brought him here because he has a recurring dream about a man 'out back of' the restaurant of whom he is terrified. Herb ultimately suggests that they venture behind the Winkies to discover whether the man is in fact there in order to 'get rid of this god-awful feeling.' They do so, Bonnie Aarons – who is credited only as the bum - appears from behind the building in heavy and grotesque makeup, and Dan collapses to the floor. We then cut to another shot of Rita asleep.

Cross-cutting between diegetically co-existent events to intimate parallel action is of course a technique crucial to the classic realist film, and no-one proves more eloquent on the subject than Eisenstein when he describes 'cross-montages...used

with the...intention of expressive sharpening of idea' as 'an interweaving of two lines...whose climax is reached through a continuation of...cross cutting...with the significance always dependent on the juxtaposition of the two lines' (Eisenstein, 12-13). However, in the case of the sequences described above, the recurrence of a scenario bookends scenes whose relationship to one another is unclear, and thereby an intimation of parallel action does not convey explicable significance in the sense of Eisenstein's 'expressive sharpening of idea.' The portent which would accompany fixed significance - for instance if Dan and Herb's conversation pertained to Rita - however, remains intact, but its power now serves ambiguity.

Another common formal facet of the classic realist film's composition which Lynch employs extensively - as is evident from much of my textual analysis thus far - is the eyeline match construction. In the wider corpus of the post-1968 scholarship from which this book's premises arise, it is often argued that the eyeline match is integral to the stable and unquestionable nature of the metalanguage, because it works to maintain 'the illusion that what is shown has an autonomous existence independent of...any coercive gaze' (Silverman, 200). It apparently does so by intermittently answering the viewer's question of 'whose gaze controls what it sees,' thereby answering the question 'in a manner that the cinematic illusion remains intact' (Silverman, 200).

I would in fact argue that, when watching a classic realist film, one's comfort in one's omniscience is thus that the autonomy of the cinematic image as preceding articulation is never really thrown into question. It, however, is undeniably the case that the eyeline match is crucial to the manner in which the classic realist film maintains its presentation of an unproblematic reality. It reinforces the notion that the metalanguage is the bearer of unassailable truth, which encompasses everything that the characters - with their limited individual perspectives - can

see. As Heath writes, 'there is no radical dichotomy between subjective point-of-view shots and objective non-point-of-view shots; the latter mode is the continual basis over which the former can run its particular organizations of space, its disposition of the images' (48).

In Lynch's films, however, while the eyeline matches are generally formally identical to those pervasive in the classic realist film, it is not always possible to easily explain the eyeline match shot as either portraying a notional overriding reality from the perspective of a character, or as product of the character's impaired mind. In the first third of *Lost Highway*, the aforementioned bizarre moments featuring the Mystery Man force a spectator approaching *Lost Highway* as the elucidation of a coherent diegesis to 'try to explain or motivate this fundamental discrepancy in the film's narrative', and ask the question 'Is Fred simply delusional?' (Buckland: 2009, 48). In both cases, Fred encounters the Mystery Man in a manner which seems impossible as according to the film's established diegesis, and so delusion seems to be the only explanation if the film is to 'make sense'. In the first, Fred sees the Mystery Man's face upon Renee's body in bed; in the second, Fred meets the Mystery Man at a party, and the enigmatic character thrusts a mobile phone into Fred's hand and asks him to call his home telephone. The Mystery Man then answers Fred's home telephone, despite being stood in front of from.

However, if one interrogates the former instance – which is most easily explained away as a momentary hallucination on the part of Fred – such an interpretation is nevertheless problematic. Even without analysing this scene, one might argue that - insofar as a diegesis has been elaborated - we have no reason to assume that Fred would experience these hallucinations and, subsequent to the scenes, we are given no immediate reason to believe this either. He has been portrayed as neurotic, yes, but certainly not insane. Within context and under formal scrutiny, though, other

eyeline match.

Another way in which scenes in Lynch's films are constructed as according to classic realist visual rhetoric, but utilise its tropes ambiguously, is in being composed in a manner which leads a viewer to expect something in particular to proceed, which then does not occur. Again, the sense of significance which these formal aspects would convey in a classic realist film remains intact, and again this sense of significance is without a definite signified. Exemplary of this tendency in Lynch's oeuvre are sequences early in the first thirds of *Mulholland Drive* and *INLAND EMPIRE*. The sequence in *Mulholland Drive* occurs subsequent to the scene – referred to above - in which Rita survives and escapes from a car accident. The sequence features a team of firemen and detectives at the aftermath of the accident. In a two-shot, Detective Harry McKnight (Robert Forster) and Detective Neal Domgaard (Brent Briscoe) flatly and impassively exchange lines concerning something in a polythene bag, and the scene concludes with McKnight stating that there might be someone missing, and magisterially surveying the lights of Los Angeles. These two actors never appear in the film again, but the scene gives the impression that they will both - and McKnight especially - be of major significance in that which follows.

The sequence from *INLAND EMPIRE* begins with the scenes which I analyse above in reference to the film's fundamental diegetic instability: the scene of The Lost Girl watching television, followed by the scene of the anthropomorphic bunnies exchanging banalities which ends with the male bunny leaving and entering a baroque drawing room before disappearing. The next scene features two men – The Phantom and an older man named Janek (Jan Hench) – in this room wearing business suits. They speak in Polish, with Janek placidly asking The Phantom if he's looking for an opening and The Phantom angrily and anxiously asserting that this is the case.

In her article on the film for *Film Quarterly*, Nochimson writes

that each of these scenes could be 'flatfootedly conventional expository hooks':

> The scene in the hotel room arouses spectatorial anxiety for the woman, an orthodox enough prompt for narrative engagement; similarly, as the male "rabbit" in the television sitcom announces that he has a secret, he evokes another common way of constructing suspense. The two foreign men, speaking tensely about looking for "something," might be in an international thriller. (11)

While I would argue that there is absolutely nothing 'flatfooted' about these scenes - and neither would there be if they were situated in a more coherent context - it is certainly true that they use conventional formal means to intimate portent which is never given fixed significance. Unlike McKnight and Domgaard in *Mulholland Drive*, many of the characters within the sequence from *INLAND EMPIRE* do reappear many times, yet their reappearances are always extremely ambiguous.

The reappearance of characters and objects which are never given fixed significance is central to the way in which many of Lynch's films - and *Mulholland Drive* and *INLAND EMPIRE* especially - are holistically structured utilising the visual rhetoric of the classic realist film, and yet do not engender a mode of reception which considers their scenes primarily as nexuses in a chain which might all be evaluated as according to their conclusion. Many of the characters and objects which appear in disparate contexts within these films - while of course identifiable 'beyond the brute material presence of light and shadow on a plane surface' (Sobchack, 6) - often remain ambiguous in terms of some notional diegetic significance. Their recurrences, however, are thusly placed that they lend the films a sense of structure. Indeed, Lynch might be interpreted as referring to this himself when he - again making an analogy with music -

compares the way he would like people to experience *Mulholland Drive* 'to the way people understand music. After the music starts, a theme suggests itself. This theme disappears, but when it again returns, it's so much greater than what's gone before' (qtd. in Wilson, 137).

Heath writes that, in the classic realist film, 'systems of repetition are tightly established...on the line of a narrative action that holds the repetitions as a term of its coherence and advances with them...its sense of difference, of change, of the new' (168). He contrasts this form of repetition with that employed by structural/materialist film, whose visual rhetoric is of course diametrically opposed to that of the classic realist film. Heath writes that in structural/materialist film, we find 'repetition that is 'in itself', not subsumed by a narrative and its coherence, that is literal, not caught up in the rhymes that habitually serve to figure out the narrative film' (169). He concludes that repetition in structuralist/materialist film is tantamount to 'a network in which the vision of the I, the ego, is no longer confirmed as the master view', in contrast with the classic realist film's placement of the spectator as omniscient (Heath, 169). I argue that the use of repetition in *Mulholland Drive* and *INLAND EMPIRE* engenders a mode of reception somewhere between the two which Heath delineates. While the manner in which the repetition is deployed gives the impression that it is indeed 'a term of [the films'] coherence,' providing a sense of continuity and unity as the films change and progress, it certainly subverts the spectator's status as the master view, insofar as the repetition of motifs in different contexts furthers the ambiguity of their significance.

In the final half hour of *Mulholland Drive*, we are ostensibly presented with a different diegesis to that in which the action has hitherto taken place. In this section, many of the characters and motifs which appear throughout the film reappear in different roles or capacities. Watts reappears as an extremely dishevelled

and disillusioned actress named Diane Selwyn, which is the name of a corpse in an earlier scene; Harring reappears as Camilla Rhodes, which is the name of the girl forced upon Adam Kesher's (Theroux) film in earlier scenes; and many of the other characters and motifs which have appeared throughout the film – often with little or no expository information – reappear. This is most notable within a party scene, in which a number of actors – Melissa George, Angelo Badalamenti, Monty Montgomery – briefly reappear. These reappearances lend the film a certain sense of satisfactory conclusiveness, as they would if this coda revealed some final, fixed significance of these characters and motifs. It does not, however.

An example of this is the motif of the blue key. In the film's first third, Rita finds a large blue key in her bag. This blue key is taken by Betty and Rita to be a major clue towards discovering Rita's identity. Later, Betty discovers a blue box in *her* bag. The large blue key opens the blue box but the content is never revealed. The film, then, has consistently drawn attention to this blue key with the rhetoric of the classic realist film, yet it has never been given fixed significance. In the first scene of the film's final half-hour, there is a sustained close-up of a Yale key which has been painted blue. This close-up of course encourages the audience to make the connection between these two blue keys, and thereby lends the inanimate object a sense of portent. At this point, however, this blue key is not even acknowledged by anyone in the film, only the camera pays it attention. In the sustained close-up, the key takes up the entire bottom left-hand quarter of the frame, and attention is drawn to it because every-thing else in shot is either deep black (the centre of the table, upon the wooden border of which the key is lying), or out of focus (the table's wooden border). The key is sharply defined, outlined by a thick shadow, and every ridge and scratch upon its surface is highlighted. Yet in this scene it is not given fixed signif-icance, and some relationship to the blue key which features

earlier in the film is certainly not elaborated.

The same – or an extremely similar – blue Yale key appears subsequently, in a scene in which Diane seems to be arranging a hit on Camilla. The hitman, Joe Messing (Mark Pellegrino), shows her the key, and says she'll find it 'when it's finished'. When Diane enquires as to what the key opens, Joe simply laughs at her and the scene ends, preserving the key's ambiguity. Later, the key appears in Diane's apartment again, in the same place as in the earlier scene. This time, Diane *is* staring at it, and one might assume that this is indicative of her intense guilt about Camilla's murder, Joe having told her that she'd find the key when the hit was completed. However, the deeper diegetic logistics of such an interpretation raise further questions which are not answered (for instance, what necessity would there be for such a calling card? Surely Diane would hear of Camilla's death anyway) and an explicable connection between this blue key and the blue key present throughout the rest of the film is still not made.

There is one - widely accepted - reading, however, based on the fact that the segue between the first two thirds of the film and this coda is Diane waking up, which ostensibly clarifies and explains the relationship between the characters and motifs in the majority of the film with their counterparts in its coda in terms of a fabula occurring in a coherent diegesis. This reading is predicated upon the idea that the majority of the film is the dream of Diane, and that the film's last half hour presents her bleak reality and eventual suicide, with the recurring characters and objects having appeared in the first two thirds of the film in the manner in which significant people and items from a person's life appear in their dreams. This reading is certainly convincing to an extent, but it is not unproblematic, and I think certain issues risk discrediting it entirely as a coherent final reading of the imagery.

Above, I discuss the audition scene in the film's second third,

referring to the way in which it problematises the metalanguage's incontestability, because that which is apparently artificial seems real, and that which is apparently real seems artificial. The same is true for the distinction between reality and dream if one accepts the theory that Diane's waking up marks the end of a dream. For a start, there is no distinct difference in the cinematography of the 'dream' and 'reality' sections – exemplified by the parallel car journeys taken by Rita and Diane - and, in fact, in terms of coherent linearity, the 'reality' 'feels like a dream: it is fragmented, surreal, and unpredictable' (Wilson, 141).

While *Mulholland Drive's* 'dream' sequence features a significant amount of seemingly non-sequitous scenes and many examples of characters acting in inexplicable or unnerving ways, there are no examples of the kind of spatio-temporal subversion which I analyse above in scenes from *Lost Highway* and *INLAND EMPIRE*. Within the first ten minutes of *Mulholland Drive's* coda, however, there are two notable instances of such rupture. The first occurs when Diane is in her kitchen. In a closeup, she looks into off-screen space. Her face contorts into a hideous grimace of agitated pleasure and she whispers 'Camilla'. A reverse shot shows Camilla smiling. We then cut back to Diane, who says 'You've come back!', but her expression soon changes to one of horror. In the subsequent reverse shot, Diane is standing where Camilla was. She seems to look disparagingly at herself and starts making coffee. We do no return to the Diane who is ostensibly still standing at the other side of the room, she has seemingly disappeared.

The second occurs when Diane, distraught, is engaged in a furious act of masturbation. Blurred P.O.V. shots of her ceiling are intercut with close-ups of her desperate face, as she strives to reach orgasm but instead seems to cause herself pain. She is interrupted by the ringing of her phone, and we then cut to a close-up of the phone. We then cut to a wider shot, which shows Diane

venturing through a door towards the ringing phone. While continuity editing creates the impression that she is walking into this room from the living room, in the prior shots she was wearing a white top and denim shorts and was not wearing makeup. Now, however, she is wearing makeup and a black dress.

Also, in some cases, the characters' incarnations in the film's 'reality' section seem far more suited to the oneiric than their incarnations in the 'dream' section. This is most pertinent in terms of an elderly couple performed by Jeanne Bates and Dan Birnbaum. These two characters - perhaps more so than any others in the film - are never given any substantial form of fictional identity, save for when Betty refers to the woman as 'Irene.' As in the case of the blue keys, the couple's presence is firmly highlighted by the film in both of their appearances, yet in both cases they are of no fixed significance. When the elderly couple first appear, they are escorting Betty out of LAX. The scene ends with a shot of them sitting in the back of a taxi and grinning maniacally. While their appearance here is certainly disconcerting, it is far less bizarre than their appearance in the film's coda, where they lack personas to an even greater degree. In this scene, the bum sits behind Winkies, the blue box beside her. The elderly couple apparently emerge from the blue box and crawl under the bottom of Diane's apartment door. Suddenly full-size, they chase her down a corridor and into her bedroom, where she proceeds to shoot herself in the head. In this second appearance, their performances, and all the cinematographic elements, contrive to convey them as hellish, terrifying and – crucially – nightmarish.

That the bum and the blue box also appear in this latter scene is also very important when considering the distinction between the 'dream' and 'reality' sections. The blue box and the bum are two of the most enigmatic features of the film's first two thirds. They are two elements which one would think were entirely

native to a dream. Yet in this sequence they apparently appear in 'reality', and in the most dreamlike manner yet: at night, bathed in artificial red light and swatches of smoke. Another element of the film's first two thirds which seems as if it could belong only to a dream is Club Silencio. However, the very last scene in *Mulholland Drive* takes place there. The club is empty save for a woman with white makeup and blue hair (Cori Glazer) in a box seat. She says 'Silencio', and we fade out. As Wilson writes, 'The return of these images is confusing. If Diane is now dead, why would her dream images appear on the screen?'(159)

Wilson then proceeds to hypothesise as to whose dream the 'dream' sequence of the film *actually* is, but I of course would argue that this is beside the point, because – as Rodley writes – 'with *Mulholland Drive* Lynch has made the very notion of 'dream' versus 'reality' an irrelevant opposition' (267). That *Mulholland Drive* consistently connotes significance, yet seems to have no final signified - almost inviting a viewer to interpret it, but always thwarting coherent interpretation - is integral to its capacity to destabilise its spectator, and ultimately engenders a mindset for which the film becomes 'an adventure of perception.' Integral to this is the recurrence of characters and motifs in different contexts, highlighted by the visual rhetoric of classic realism, but given no fixed significance in their connections.

This process, however, is more fully realised in *INLAND EMPIRE*, which destabilises its spectator to such an extent that he/she is all but forced to surrender hermeneutic effort and adopt a mode of reception which does not strive to 'know', and yet which is still receptive to the classic realist film's means of signi-fication and affect. Within the film, so many figures appear in more than one incarnation, and so many motifs appear in different contexts, that it seems that those characters and objects with only one identity and manifestation are the exceptions. While in *Mulholland Drive*, the delineation between sections of the film in which actors take on different fictional personas is

distinct, in *INLAND EMPIRE* – as I explore in the last chapter - characters' identities change from scene to scene and, at times, within scenes. Similarly, the motifs and objects which reappear do not take on their different contexts either sides of a dividing line, but are dispersed throughout the film.

Exemplary of this is a scene in the film's second third wherein Dern – now distinctly as Susan – storms into a room in Billy's mansion. As the scene progresses, other elements from *INLAND EMPIRE* which have hitherto appeared are intertwined using cinematographic techniques familiar from the classic realist film, yet diegetic connections between these elements and the scene are never explicated. The sense of portent which would accompany these cinematographic techniques if they signified something definite, however, is maintained. The scene proceeds thusly: Billy's wife, Doris Side (Julia Ormond), and their son (Scout Alter) are sitting with a doctor (Alexi Yulish), who jovially recommends that the unwell child should take 'maybe two' more days off school. When Susan emerges in the doorway, she looks shocked to see Doris and the child there. The impression seems mutual, as Doris says, in a confused but faux-amicable tone, 'Susan...what are you doing here?' Then, subsequent to the emergence of Billy, there proceeds an altercation, which results in Doris hitting Susan repeatedly and Billy asserting that Susan should leave. Susan replies to this by saying 'I don't care...it's something more...', which she repeats, before we cut to a slow zoom into Doris's shocked face, as if she is suddenly remembering something long repressed, or as if a realisation is dawning on her.

A match cut dissolve to a close-up of Ormond from an earlier scene – in which her character is a woman in an interrogation room who speaks of a man who 'moved his hands' and hypnotised her to commit murder – then follows, before we cut to a shot of The Phantom, here appearing in the form of a dishevelled man in a bar; then dissolve to a shot of Ormond as a woman

lying disembowelled and dead, which has appeared earlier; then dissolve back to the woman in the interrogation room; then dissolve to The Phantom in the bar, who erratically moves his finger (is he the man who 'moved his hands'?) and appears to speak in accelerated nonsense. With this accelerated nonsense remaining on the soundtrack, we cut back to the room in the Side's mansion.

In this scene, then, cinematographical techniques which would be deployed in the classic realist film to intimate flash-backs and consolidate various elements in reference to a wider diegesis are present, but they do not work towards such definite ends. They connect formerly disparate scenes and motifs from the film without contributing towards the cumulative cultivation of a fabula, and thus the scenes from earlier in the film to which the scene makes reference might not be judged in light of this scene, as would be the case if the cinematographic elements *did* reveal information which lent these scenes new meaning.

Above, I analyse the first sequence featuring The Lost Girl twice – in reference to how, in context, it typifies the fundamental diegetic instability of *INLAND EMPIRE*, but also in reference to the way in which it could conceivably be taken from an entirely conventional classic realist film – and it is useful to return to the scene now, bearing in mind observations made in both of these analyses. As I delineate above, in the scene we see a shot of Visitor #1 walking up a pathway on the television screen and subsequently, after the scene featuring rabbits and the scene of dialogue between Janek and the Phantom, we see Visitor #1 walking up the same pathway, seemingly unmediated. That we recognise Visitor #1 from a few moments before lends her reappearance an ominousness which is not due to any fixed significance, for we have no idea who this character is, and – aside from the fact that she is Nikki's new Eastern European neighbour with a penchant for cryptic riddles – a fictional identity is not subsequently prescribed to her.

Throughout the film, motifs are lent this sense of significance through their recurrence and – setting aside their multitudinous connotation in respect to the individual viewer's experiences – solely their recurrence, as opposed to what they might 'mean' in terms of that which Jacques Rivette refers to as a classic realist film's 'architecture of connections' (qtd. in Hillier, 79). An ironic example - in that it utilises letters, symbols usually deployed for definitively semantic means - is the motif of the letters 'AXX o N N'. The letters 'AXX o N N' first appear on the cusp of the film's first and second thirds, when Dern's character walks down an alleyway towards her car carrying a bag of groceries. She places the groceries in one of the car's back seats and notices something off-screen. In an eyeline match, we see a metal door with the letters and an arrow scrawled onto it in chalk. We then cut to a shot of Dern's character staring at these letters, then an extreme closeup which progressively zooms into the letters, and then another reaction shot of Dern's character, who walks off-screen. The following shot is a slow-motion zoom into the letters.

Before these letters appear in sequence again, the first of them appears in close-up in a room, painted on the wall. The letters then appear in another eyeline match, scrawled onto the wall in chalk with another arrow in the aforementioned scene in which Dern's character seems to see herself across the road. They finally appear at the film's climax, printed on a door which Dern's character enters before a climactic altercation with The Phantom. In all of these examples, attention is firmly drawn towards the letters, but the impetus for such foregrounding remains oblique.

There are another two motifs which recur many times throughout the film – a screwdriver and a red light bulb – which are particularly notable because they both appear prominently in a sequence in the film's second third, the marked sense of import of which is largely product of the fact that these motifs have appeared earlier. While I above incidentally refer to the screwdriver's presence in the scene in which a character performed by

Dern sees a character performed by Dern over the road on Sunset Boulevard, the first scene in which the screwdriver appears is the above mentioned scene in an interrogation room, in which the woman performed by Ormond is interrogated by Detective Hutchinson (Robert Charles Hunter). The woman is clearly in pain. She says she's been hypnotised and that she is going to kill someone. When asked who she is going to kill she says she doesn't know. When asked how she is going to kill her victim, she answers that she will perform the murder with a screwdriver. She then lifts her shirt to reveal a screwdriver stuck in her stomach.

The screwdriver makes its next prominent appearance when Dern's character climbs a staircase in a rundown stairwell to an interview – scattered throughout the film essentially as a series of monologues – during which she narrates various grisly stories involving abusive men. When she first reaches the room in which her interview takes place, she makes comments concerning the arduousness of climbing the stairs. What she does not mention, however, is that she is carrying a screwdriver. The screwdriver next appears in a scene in the same stairwell, as The Lost Girl – or, at least, Gruszka in some incarnation – climbs the stairs with trepidation, clutching the screwdriver in front of her, and it later is the weapon with which character performed by Ormond fatally wounds a character performed by Dern.

The first time attention is explicitly drawn towards a red light bulb occurs when Dern's character first enters Smithy's House. She ventures into a bedroom and an eyeline-match with a lamp with the red light bulb on a bedside table follows, with the shot of the lamp being held for a length of time which is seemingly inordinate to its significance. A few minutes later we see - from a corridor in Smithy's House - an apparently empty room become illuminated with red light. We then cut to a shot of another lamp with a red bulb. Lamps with red bulbs appear in other contexts throughout the film - notably, there is one in the anthropomorphic rabbits' living room.

As mentioned above, the scene in which both of these motifs appear occurs in the film's second third. In the scene, Dern's character approaches a shack calling 'Hello.' She receives no reply, but The Phantom emerges from behind a tree with a red light bulb in his mouth. We then cut to close-up of the red light bulb, before cutting to a shot of the lamp with a red light bulb from earlier in the film. Dern's character then hastily grabs a screwdriver among some detritus before fleeing. Neither diegetic significance for nor a relationship between these motifs is conveyed in this sequence. That the audience, however, is encouraged to make the connections – explicitly in the case of the red light-bulb - raises the same sense of portent which would be cultivated if these motifs were given fixed significance.

Indeed, Lynch tells an anecdote about this scene which reveals that it is indeed pivotal in terms of *INLAND EMPIRE's* motifs, and is also telling in respects to the ambiguity of these motifs' significance. Lynch recalls that this scene was one of the first shot, before he even knew that *INLAND EMPIRE* would be a feature, when he was just planning to film assorted sequences 'as an experiment for the Internet' (139). When Majchrzak arrived at Lynch's house prior to shooting, he had on his face a pair of 'goofy glasses' which he planned to wear in the scene. Lynch did not approve whatsoever, yet Majchrzek was insistent that he needed a prop, and so Lynch went into his office and opened his cupboard to find a little piece of broken tile, a rock, and a red lightbulb. He then, apparently, took these things out to Majchrzek and the actor chose the red lightbulb, which resulted in the scene described above (Lynch, 140-141). If this account is to be believed, the fact that the red lightbulb is such a prominent element in the film is essentially aleatoric, and not in accordance with some wider diegesis.

The constituent motifs of *INLAND EMPIRE*, then, comprise a totality, but this totality 'is not a structure that integrates the sum of its parts', because it is not a 'preconceived totality' to which

the individual elements mould themselves (Adorno, 178). The repeated motifs contrive a unity, yet they are not cumulative to the articulation of a coherent filmworld, over which the audience might be positioned as omniscient. Instead, the film – as I have explored is the case throughout Lynch's oeuvre – employs the visual lexis of classic realism to ambiguous ends, evading disjointedness and leaving the viewer epistemologically destabilised as an artwork in completeness.

Only the Now

Lynch's films, then, problematise the possibility of a spectator taking an omniscient perspective in relation to them, despite their predominately third-person mode of address. Instead, they might engender a mode of reception whose preoccupation is not the information provided by the scenes – which is often contradictory and incoherent - but the audiovisual texture and multitudinous connotation of the scenes' elements.

By this I'm certainly not implying that consideration of elements as divorced from rigid meanings is impossible when watching films whose scenes contrive to convey coherent fabulas from the third-person perspective. Writing in reference to the classic realist film, Siegfried Kracauer explores cinema's capacity to capture 'fleeting impressions – "the shadow of a cloud passing across the plain, a leaf which yields to the wind"' (254). He writes of these ephemera as 'things normally unseen': those elements of our perceptual reality which are 'the least permanent components of our environment' (Kracauer, 252-254), and thereby likely to be disregarded by a mindset whose concern is the utility of each moment in reference to a perceived outcome. Kracauer claims that 'such impressions may haunt the moviegoer long after the story they are called upon to implement has sunk into oblivion' - presumably in contrast with more forgettable moments which explicitly serve the function of furthering a film's fabula - and cites 'the manes of the galloping horses – flying threads or streamers rather than manes – in the chariot race episode of Fred Niblo's *Ben Hur*' and 'the fiery traces of the projectiles that tear in the night in *Desert Victory*' (254). I, however, argue that Lynch's oeuvre is rare in terms of film which predominately employs classic realist visual rhetoric, because his works often seem almost to encourage this contemplation of elements as apart from their functionality or codified meaning.

Greg Hainge acknowledges this when he writes of how *Lost Highway* 'concentrates the viewer's attention on the specific acts of smoking, talking and love-making' (146). Hainge claims that, when watching *Lost Highway*, 'we care little for who is making love to whom in the film for we concentrate on the texture of the image, the interplay of two bodies; so sensuous are the lips it matters little what they are saying; and so what if smoking kills you?'(146). Hainge's analysis seems to assert that *Lost Highway* fulfils the ideal end of art as posited by Victor Shklovsky in his essay *Art as Technique*. In the essay, Shklovsky writes of how 'as perception becomes habitual, it becomes automatic.' Employing the example of holding a pen, he argues that if one remembers the sensation of doing so for the first time 'and compares that to his feeling at performing the action for the ten thousandth time,' this habituation becomes clear. 'In this process' Shklovsky writes, 'things are replaced by symbols' and 'we do not see them in their entirety' (218), and this assertion might serve as a neat summation of that which is symptomatic of the dominant discourse's 'regulative thought' which - as Adorno and Horkheimer write - 'tabooed the knowledge which really concerned the object' (14). Shklovsky argues that, in the face of this habituation, 'art exists that one may recover the sensation of life; it exists to make one feel things, to make the stone *stony*' (219). He writes that art might 'impart the sensation of things as they are perceived and not as they are known' (Shklovsky, 219), and thereby engender a mode of reception which does not value things as according to a pre-given normative 'knowledge'.

Since the medium's infancy, the potential for cinema to achieve this end has been recognised. For example, in an essay on film form from 1928 entitled *Sorcery and the Cinema*, Antonin Artaud expresses sentiments akin to Kracauer's notions of 'things normally unseen' when he writes that 'any image, even the slightest and most banal, is transfigured on the screen. The smallest detail and the most insignificant object take on...the life

that pertains to each of them...one that tends to become ever more independent and to detach itself from the habitual meaning these objects have' (103). Similarly, Jean Epstein writes of how on the cinema screen we might see – to take his examples – animals, plants, stones living their mysterious silent lives, alien to the human sensibility' (qtd. in Moore, 23).

Throughout film history, works have achieved such defamil-iarisation through technically figurative modes which formally differ from classic realism by treating the indexical reality which comprises their imagery in a manner which is primarily concerned with textures. Such films might thereby engender a gaze which conceives of 'its object as bereft of an established symbolic and ideological value' and encounters it in terms of its '"isness" (for Stokes) or, what Gidal calls, its "there-ness"' (O'Pray, 32). Such works – as is the case with, as I acknowledge above, the abstract and diary film – eschew third-person rhetoric entirely, and exemplary of this tendency is *Les Oursins* (1958). *Les Oursins* is a film by Jean Painlevé which is comprised of delicately photographed images of sea urchins, often in extreme close-up. Their many rubbery spines quiver in the water; the light rendered a burnt umber as it refracts through the globular creatures' coating of appendages. When watching *Les Oursins*, one might lose oneself in the visual texture of 'things normally unseen', and this mode of reception is engendered through form which is not necessarily conducive to intellectual compre-hension.

At times, defamiliarisation in the work of Lynch is cultivated in a manner similar to such films. In such instances, visual rhetoric alien to the classic realist film is incorporated into works which otherwise employ the formal tropes of classic realism. It is to this which Jerslev refers when she writes of Lynch's 'ongoing aesthetic endeavour' to 'attempt to produce in close-up a sensuous feeling of the physical materiality of the surfaces of the depicted objects and thus to deprive the objects of their precise

referentiality and their codification in the world of objects' (153), and this tendency is confirmed by Lynch himself when he refers to his fascination with texture at the expense of codified meaning:

> I don't necessarily love rotting bodies, but there's a texture to a rotting body that is unbelievable. Have you ever seen a little rotted animal? I love looking at those things, just as much as I like to look at a close-up of some tree bark, or a small bug, or a cup of coffee, or a piece of pie. You get in close and the textures are wonderful. (121)

This urge to extrapolate an object's texture from the role of definite signification is often markedly manifest in his films' opening sequences. It is not uncommon for a classic realist film's opening sequence to be the point when formal experimentation is most acceptable[4], and this is most likely why Lynch often deploys such sequences before his films' narratives begin. As Chion acknowledges, 'very early on, Lynch acquired the habit of opening his films...with moving textures', referring to the 'mushrooming white smoke' of *The Elephant Man* (1980); the 'sand dunes and the wind raising curtains of sand' which open *Dune* (1984); the 'blue velvet curtain [which] slowly undulates in the credits of *Blue Velvet*...The spiralling flames in the credits of *Wild at Heart*'; and the 'corpuscular movement in blue tones' of *Twin Peaks: Fire Walk With Me* (1985).

Indeed, within the first few minutes of *Blue Velvet* - subsequent to Tom Beaumont (Jack Harvey) suffering a stroke and collapsing - we venture into his lawn to witness, in close-up, the activity of the insects which inhabit it. We proceed through blades of grass, which appear the size of branches, until we reach a mass of beetles. Set to acutely palpable sounds of guttural skittering, these creatures seemingly scramble over one another, a mass of limbs and shiny shells. This sequence very distinctly recalls films such as *Les Oursins*, and certainly seems to reveal these creatures'

'mysterious silent lives, alien to the human sensibility.'

Mulholland Drive, also, opens with two sequences – a scene of dancing couples and a scene of a bed with unkempt sheets – which defamiliarise their content through formal means divergent from classic realism and are reminiscent of particular experimental films which do so. The first scene is reminiscent of *Adebar* (1957) by Peter Kubelka, and the second scene recalls *Epilogue* (1978) by Gidal. As is evident from quotes employed above, Gidal is vociferous in his refutation of pre-given norms, and Kubelka, also, seems to ground his praxis in a sceptical approach towards that which is presented as normative or essentialist.[5]

Set to a piece of swing jazz by Angelo Badalamenti, *Mulholland Drive's* scene of dancing occurs in a definitively extradiegetic timespace. The only intimation of setting is a background of flat mat purple monochrome, in front of which couples - some in silhouette and some not – dance. While it is unclear whether *Adebar* provided inspiration for this scene, it is difficult to believe that anyone familiar with both works could watch the opening scene of *Mulholland Drive* and not be reminded of Kubelka's film.

As Sitney writes, 'the subject matter of *Adebar* is dancing' (127). While the scene from *Mulholland Drive* features music, *Adebar* is silent, and while some of the dancers in the scene from *Mulholland Drive* are not in silhouette, all of the dancers in *Adebar* 'seem like shadows' and 'the only guide to their depth is the eclipsing of rear dancers by those in the foreground…otherwise the images look almost flat' (Sitney, 295). Focus, then, is largely drawn towards the movement of the dancers, and one might indeed say that the film is simply about dancing as opposed to *who* is dancing or *why* they are dancing. The inclusion of music and the fact that not all of the dancers are in silhouette provides the scene from *Mulholland Drive* with a little more context than *Adebar*, but one could similarly say that it is simply about

dancing.

The little sense of screen-depth which is cultivated by the scene is confused by the manner in which dancers appear within the silhouettes of other dancers, disappear in an instant while those which appeared to be moving within the same space continue to dance, and emerge in fade-ins over the pre-existing action. All this is conducive to creating a visual cacophony of motion and a spectator is bombarded with movements and yet deprived of context. Because of this – instead of attempting to orient him/herself in a position of omniscience in relation to the action – the spectator might simply appreciate the movement for the sake of itself. In this scene, the motion of dancing is treated as a texture, and so might by appreciated for its palpable qualities through kinetic empathy.

The second scene is conveyed in one shot, filmed with a visibly handheld camera and soundtracked by cavernous drones and unidentified feverish breathing. The first frame is extremely out of focus, and it is only after a few seconds that it becomes clear that we are watching an empty bed. In the last third of the film - when Diane wakes up face down on a bed with the same colour sheets - one might conclusively attribute this first shot to her perspective, but this is certainly not information which colours an audience's experience of this shot upon an initial viewing, and even for one familiar with the film, this connection is still markedly ambiguous and does not necessarily bestow upon the shot stable diegetic significance.

Epilogue is similarly filmed with a visibly handheld camera, and many of its frames are extremely unfocused. Beginning with the blurred image of a picture on a wall, we move to the right across a room until we reach a doorframe where, subsequent to a subtle superimposition of later action, we rest for a few seconds. We then move further right and there is a cut, but the continuous motion of the new shot to the right makes this cut barely discernable. We then proceed to hover upon what appears to be

some kind of chest, upon which are a number of objects including a magazine and an apple. Another subtle superimposition - a shot of the same chest from a different angle - then appears, and the film dissolves into this new shot. We then proceed further right across bed sheets, which one might only really recognise as thus because of what we have seen before, otherwise the shot could be some kind of snowy landscape from an aerial view. We then continue along the bed onto a bedside table, which dissolves into the unfocussed image of a pillow. This image is then held for a few seconds, before the film returns to the bedside table. This sequence is then looped a number of times. The film is silent, soundtracked only by the sound of vinyl crackle, which – despite perhaps being the product of contemporary technological necessity - nevertheless serves to imbue the film with a certain atmosphere which it would not have were it to feature the genuine ambient sound of the bedroom. In the scene from *Mulholland Drive* and for the entirety of *Epilogue*, unfocussed cinematography, intense proximity of the camera to the films' respective beds and audio elements defamiliarising that which would otherwise be mundane context encourage viewers to appreciate the beds in their particularity rather than simply as visual signifiers.

Similarly, *INLAND EMPIRE* begins with such formal defamiliarisation. The very first scene of the film is comprised of extreme close-ups of a spinning record. The stylus casts a vast, intimidating shadow, and light plays on the surface of the rotating vinyl as we hear a subtly haunting score, the sounds of howling winds, and the loud crackle of a scratched record. Again, a mode of reception which appreciates elements in their particularity and sensuousness might be engendered despite the relatively quotidian nature of the scene's content. Soon after this scene, the opening sequence which I discuss multiple times above in reference to its engagement with classic realist visual rhetoric commences. Yet throughout its runtime, *INLAND EMPIRE*

features prominent sequences employing visual rhetoric averse to that of classic realism to a greater extent than is common in Lynch's work, a factor which I think reinforces my conclusions in the last chapter as to *INLAND EMPIRE*'s capacity to destabilise the spectator to a greater extent than any other film within Lynch's oeuvre.

One of the most notable of these is a brief but arresting sequence which serves as a segue between the film's second and final thirds. This scene features up to three layers of imagery superimposed over one another, but one or more of these layers are intermittently removed on a frame-by-frame basis to create a flicker effect. One layer features Dern's character sitting in a room surrounded by the group of girls. This imagery is shot very erratically, with the visibly handheld camera shaking furiously. The other layers comprise neon lights recorded in various ways, most strikingly with low shutter speed, which creates the impression that the lights are dancing and leaving trails in their wake. The result of all this is supremely bewildering in terms of an audience's topographical relationship to the represented space, but incredibly invigorating if one engages with the scene on the level of its visual dynamism, that is to say primarily on the basis of perception.

However, employing visual rhetoric which is radically averse to that of the classic realist film is not the only way in which works by Lynch cultivate ripe ground for a mode of reception primarily based upon direct perception and affect. As I explore in the immediately previous chapter, Lynch's films often employ classic realist rhetoric to indefinite ends, and I take the use of classic realist visual rhetoric to seemingly foreshadow something, which then does not occur, as one of the major examples of this, referring to scenes from *INLAND EMPIRE* and *Mulholland Drive* in which such apparent foreshadowing is overt. On a microcosmic level, however, this is endemic in his filmmaking. Throughout his oeuvre, there are many instances of

the camera lingering 'too long' over an image in terms of its apparent diegetic utility. These shots seemingly urge the spectator to relish elements for their audiovisual texture, but do not employ formal means averse to those of the classic realist film in order to do so. A particularly notable example of this occurs in *Mulholland Drive*, in a scene in which Joe shoots Ed (Vincent Castellanos) dead in his office. As Ed's body lies face down on a desk, there is a close-up of the back of its head, and then a pan across a long horizontal strand of hair, with blood dripping from it.

The fact that the portent which this shot implies is deeply ambiguous is inadvertently reinforced by the excessive tenuousness of theories which constitute certain attempts to 'solve' *Mulholland Drive*. On one fan website, *Lost on Mulholland Drive*, a user named 'blu-riven' supposes that 'the hair is indeed an arrow, pointing us to look at the Italy poster at the opposite side of the room', concluding from this that 'Lynch is pointing us, literally, toward a connection between Ed and the Castiglianes', Italian mobsters who appear in a few of the film's scenes. For 'blu-riven', this raises the question of 'whether Joe, who is looking for Rita, is somehow in opposition to Ed and the Castigliane bros, and whether he would help her, or otherwise.' Another user - under the name 'Vickie Balamoti' - surmises that, because the 'pointing hair' is 'black, speckled with red, and...pointing at [Ed's] black book', it is implied 'that the black book is related to the call girl/prostitute profession'. Yet another user, with the pseudonym 'wasto7', claims that Ed is 'none other than the guy behind Winkies', because, according to 'wasto7', when Lynch 'focuses on the brain-splattered strands of hair sticking straight out from the exit wound', he is encouraging the viewer to make such a connection. 'wasto7' founds this assertion on the observation that 'the man behind Winkies has natty hair, hardened and dirty and whatnot', urging us to 'examine a picture of the guy in the office, then look at the guy

behind Winkies,' because, apparently, 'somehow they're the same guy.' It should be noted here, in reference to the arguments of 'Vickie Balamoti', that Ed's hair is in fact brown, speckled with beige, and that, in reference to the arguments of 'wasto7', on a literal level, at least, Ed and the bum - as the character behind Winkies is credited - are certainly not 'somehow…the same guy', since – as is noted above – the bum is not a 'guy' at all, but instead performed by the actress Bonnie Aarons.

Easy targets, maybe, but the sheer absurdity of these message-board user's arguments exemplifies the futility of a mode of reception which strives to 'know' in relation to much of Lynch's work. Their attempts to explain this shot call to mind Sontag's derisive summary of interpretation, wherein she describes a notional critic who plucks 'a set of elements (the X, the Y, the Z and so forth) from the whole work' in order to say 'Look don't you see that X is really – or, really means – A? That Y is really B? That Z is really C?'(5), and thereby blinds him/herself to the work's sensual facets, which are ripe for attention in such sustained close-ups.

The fact that sustained close-ups without dramatic impetus are idiosyncratic of Lynch's directorial style becomes particularly clear if we turn to two lengthy close-ups from episodes from *Twin Peaks's* second season, one from 'Coma', an episode directed by Lynch, and another from 'Laura's Secret Diary', directed by Todd Holland. In 'Coma', there is a scene in which Shelly Johnson (Madchen Amick) visits her comatose husband Leo Johnson (Eric Da Re) in hospital. Dr. Hayward (Warren Frost) explains to her that the wounds sustained by Leo have rendered him vegetative. Shelly breaks down crying, and Dr. Hayward kindly guides her out of the room. As he does so, an insidious drone emerges on the soundtrack and the camera begins a gradual zoom into the reflection of Leo in the mirror over the operating table. The zoom continues until the mirror almost fills the frame, and the shot is then held in close-up for a matter of seconds. Nothing changes,

sake: a mode of reception which values cadence and which considers the pauses in the dialogue as important as the dialogue. The playing field is levelled by the lines' semantic ambiguity and - to paraphrase the writings of Elie Faure famously quoted by Godard in his script for *Pierrot le Fou* (1965) - as the latter Velasquez did not paint concrete things but instead the spaces in between, one might say that this scene is as much composed of gaps between speaking as it is speaking.

I posit, then - in a movement as paradoxical as the motif of the letters 'AXX o N N' in *INLAND EMPIRE* - this dialogue might be received in a manner which has little to do with that which it definitively means. One might appreciate it for the manner in which it is spoken rather than its semantic content, and an analogous sentiment is echoed by Lynch himself in reference to the delivery of lyrics in the pop songs from the 'fifties and 'sixties which he regularly uses. These songs often 'explicitly feature banal, cliched emotional…expression' (Mazullo, 494), and when Rodley raises such issues with Lynch, the filmmaker asserts that the lyrics of these songs are certainly 'simple, *but it's not what you're saying, it's the way you say it*, and how it works as a texture against a bottleneck guitar' (127).

The period in which these songs were made 'saw the increased use, across various markets, of reverb, echo, and other sound-modifying techniques' and 'Lynch's interest in these songs seems to arise…from a certain uncanniness in their sound' resulting from these treatments, such as 'a distinctive voice, a provocative mix, a spotlighted arrangement or production' (Mazullo, 494-495). Such elements lend these songs ambiguity, emancipating their ineffably affective qualities from that which their lyrics might 'say', and when these songs are utilised in Lynch's films, they often might be said to similarly emancipate the evocative aspects of the film in question from that which its action has hitherto seemed to 'say'; from the narrative continuity which has been employed to connect its audiovisual images. In

reference to Richard Strauss's 'Im Abendrot', the piece of music which opens *Wild at Heart*, Annette Davison delineates how the work 'fails to establish the rhythmic emphasis of a regular metre', resulting in a 'quality of timelessness, or free-falling...further compounded by the abundance of notes tied across bar-lines, which creates a general sense of delay in the teleology of the lines' and 'invites the listener to be suspended alongside the music in its ethereal descent' (121). I posit that the musical interludes in Lynch's films might generally engender this mode of reception: a state of suspension, of limbo, in which one is most receptive to non-discursive affect, and does not care to position oneself as omniscient over a diegesis.

To take as exemplary a scene from one of Lynch's more coherent – though, as explored above, by no means diegetically stable – films, *Blue Velvet*, the scene in which Ben (Dean Stockwell) mimes along to Roy Orbison's 'In Dreams' occurs at a moment of great dramatic urgency within the film's narrative. After turning up at Dorothy's apartment with a gang of heavies, Frank forcibly takes Jeffrey and Dorothy to the apartment of the softly spoken and dandyish Ben (Dean Stockwell), where Frank is holding Dorothy's husband and son hostage. Once there, Frank and his associates drink beer and, when Jeffrey does not join in with Frank's toast to Ben, Frank punches him in the face, before Ben saunters over and punches him in the stomach. Subsequently - with the casual words 'Let Tits see her kid, huh?' - Frank allows Dorothy to enter a back room and see her child. Once she does so, a drone on the soundtrack accompanies a slow zoom into the closed door as we hear Dorothy's voice, desperately declaring that she loves her son. This drone continues as attention turns to Ben languidly preparing for his performance, cigarette holder in his mouth and a work light in his hand in place of a microphone. He flips the light on, the drone abruptly stops, and 'In Dreams' begins, placed in this ostensibly horrific and tense context.

As Ben performs, there are numerous cutaways to his diegetic

audience. In these shots, MacLachlan performs as Jeffrey in a manner consistent within the rest of the scene – part dejected, part terrified – but to the soundtrack of 'In Dreams' he seems like a man enchanted. Similarly, when Dorothy emerges from the back room, solemnly looking to the floor, she seems more like a somnambulist than a distressed mother. For this segment of the scene, then, one might forget the diegetic framework in which it is ostensibly placed and appreciate the ineffable atmosphere cultivated by the music for-itself, until Frank suddenly stops the cassette player from which the song is diegetically emerging.

Another particularly notable instance of music providing such a space of limbo occurs in *Mulholland Drive*, in the Club Silencio sequence cursorily mentioned in the last chapter. In the scene, Rebekah del Rio performs a stirring Spanish-language rendition of another Roy Orbison song, 'Crying', while Betty and Rita watch. As in *Blue Velvet*, the scene occurs at a moment in the film's narrative when dramatic tension is incredibly high. Through their investigations into Rita's identity, Betty and Rita have discovered a dead body, and Rita – fearful of her implication in this death – cuts her hair short and decides to wear a blonde wig. Later, Betty and Rita make love, and as they lie asleep next to each other, Rita starts saying phrases in Spanish – 'Silencio', 'No hay banda!' – with urgent monotony and her eyes snap open. Betty wakes up and asks Rita what's wrong. Rita responds by asking Betty to go somewhere with her. They then hail a taxi, which takes them to Club Silencio.

Once inside the club, a character performed by Richard Green credited only as The Magician appears onstage and declaratively shouts the same Spanish phrases which Rita was saying in her sleep, before performing an extravagant display in which he appears to orchestrate the sounds of instruments which he proclaims are being produced by a tape recording. The Magician then leaves the stage and an Emcee (Geno Silva) walks out from the wings and, in Spanish, introduces Rebekeh Del Rio. He

leaves the stage and Del Rio emerges from between the curtains, taps the microphone and commences singing 'Crying' in Spanish, entirely a capella.

No reason exists, then, for Betty and Rita to visit this club, aside from it facilitating narrative progression towards the performance by Del Rio (as I acknowledge in the prior chapter). For the performance's duration, we see nothing but close-ups of Del Rio and reaction shots of Betty and Rita, who become increasingly moved by the song, until they are both sobbing. Considering the context of the scene, their crying seems coerced by nothing but the song's overwhelmingly affective qualities, and indeed, Del Rio's rendition of the song is incredibly arresting and heart-rending in its non-discursive facets. This is reinforced by the fact that the film does not feature subtitles for those who do not speak Spanish - a category in which I am included - and yet, for me at least, the song is still deeply moving. That *Mulholland Drive*, an English-language film, dedicates three and a half minutes to a song sung in Spanish and yet provides no translation for its lyrics or solid diegetic justification for its presence might surely lead to attentions straying from the song's significance in relation to a notional fabula and towards the sensual aspects of its particularity, cultivating another space of limbo wherein a spectator might be relatively unconcerned with what has come before and what might happen next, and encounters the scene's elements in their immediacy.

There are many other scenes such as these in Lynch's oeuvre, from Maddie Palmer (Sheryl Lee), Donna Hayworth (Lara Flynn-Boyle) and James Hurley (James Marshall) – the latter apparently singing diegetically but with the female voice of Julee Cruise – performing Lynch and Badalamenti's 'You and I' in *Twin Peaks*; to the synchronised dance routine to Gerry Goffin and Carole King's 'The Loco-Motion' performed by the group of girls in *INLAND EMPIRE*. Like the scenes discussed above, all of them do not serve as propulsive plot mechanisms, unlike the scenes of songs

in classic realist integrated musicals. Instead, along with the intermittent use of visual rhetoric which formally defamiliarises its subject, and dialogue seemingly deployed as much – if not more – for its cadence as that which it expresses, these musical interludes might engender the mode of reception which Ken Jacobs, another experimental filmmaker whose praxis is – at least in part – fuelled by leftist impetus, calls for when he writes that he wishes for spectators of his films to care little for what is 'going to happen next and will Happy Ending arrive on time. No suspense! Only the now': a mode of reception which experiences that which it perceives in its sensuousness, rather than as conveying information in relation to a diegesis.

Milkless Objects of Bemused Scopophilia

In the preceding chapters, I argue that - in its fundamental diegetic instability and wilful diversions into sequences which might engender appreciation principally on the basis of non-discursive affect - Lynch's work often undermines a mindset which takes culturally developed norms to be pre-given, in spite of its largely classic realist visual rhetoric. I explore how elements conducive to such destabilisation of the spectator are present to varying degrees throughout his oeuvre, and make the case that they are most pervasive and powerful in *Lost Highway, Mulholland Drive* and *INLAND EMPIRE*, and in the latter especially. I posit that *INLAND EMPIRE* resists an unproblematically epistemologically superior mode of reception for which representations are fixed and stable to the greatest degree. It is a film which places the spectator in a position for which all pre-given norms are thrown into question, yet there is one recurring element within the film which problematises all of this, and that is the group of girls, whose significance within the work is thus that I cursorily mention them above multiple times. In this penultimate chapter, I attempt to sketch out the questionable nature of these characters in a film which otherwise resists approaches in terms of a priori knowledge to a greater extent than any other in Lynch's oeuvre.

For those filmmakers who – unlike Lynch – make such undermining of essentialism their project, deliberation over issues concerning filmic representation of women can result in supremely reductive axioms. Gidal, for instance, upon coming to the conclusion that he does 'not see how…there is any possibility of using…any image of a woman – other than in an absolutely sexist and politically repressive patriarchal way,' decided simply to no longer allow images of women into his films (49-50). He confesses that this move may be nihilistic 'because it does not see

much hope for representations of women', but he considers it necessary in the absence of any indication as to 'how these images can be separated from the dominant meanings (Gidal, 49).

Yet, as I establish above, Lynch's praxis is not theoretically determined by such political impetus, and his films are abundant with representations of women - representations which have sometimes lead to accusations of sexism. As Jana Evans Braziel writes, many theorists 'have denounced *Blue Velvet* as a sadistic male fantasy in which woman is cast as masochistic object of desire' (108), and contemporary to *Lost Highway's* release, many reviewers made the case 'that Patricia Arquette's numerous scenes played naked or semi-naked were gratuitous. The *New York Times* suggested that 'the movie exploits Ms Arquette as frankly as [Mr Eddy] does,' the *Los Angeles Times* agreed that it was 'sexually exploitative,' while *Vogue* described Renee/Alice as 'a particularly unsavoury creation" (qtd. in Hughes, 221).

Setting aside fundamental questions raised by an accusation of gratuity in relation to Lynch (when a film's scenes are thus that they do not primarily serve the purpose of coherently conveying diegetically expository information, in relation to *what* might elements be gratuitous?), it is undeniable that Arquette as Renee/Alice presents a reductive representation of woman, embodying nothing but – sometimes contradictory - paradigmatic traits of the enigmatic femme fatale. The role – insofar as one might be ascribed - of Renee/Alice certainly 'revolves around her physical attraction and the mating games she plays with the male characters,' as Sharon Smith writes of female characters in films en masse (114). Yet these male characters, in contrast, could not be said to be the headstrong figures who are 'not shown purely in relation to the female characters, but in a wide variety of roles – struggling against nature, or against militarism, or proving his manhood on the range', as Smith typifies the male movie hero (14). Even *Twin Peaks's* none-more-purposeful

Cooper, seemingly a model of male pragmatism – albeit pragmatism which utilises mysticism and transcendentalism – is, by the end of the series, indefinitely trapped in the indeterminate timespace of the Black Lodge and, as Nochimson acknowledges in her book *The Passion of David Lynch*, the 'aggressive thrust' of BOB, that show's arch-villain, 'defines as tragically problematic the unstoppable will usually portrayed as male heroism' (88).

Women may have no agency within his films, but who in Lynch's universe really *does* appear to have agency? As Rodley succinctly puts it, Lynch's 'characters are...in the land of darkness and confusion' (291). In *Lost Highway* and *Mulholland Drive*, for instance, the only figures who could honestly be said to be represented as masters of their own (and others') fates are the Mystery Man and Mr. Roque respectively, the first of whom appears as little more than a phantasmic apparition, and the second of whom is seemingly incapable of physical mobility. It therefore seems incidental that Lynch's films do nothing to buck the trend which Smith observes when she claims that 'women, in any fully human form, have almost completely been left out of film' (14), because Lynch's characters seem to have no 'fully human form' en masse, and this – their lack of fixed character traits and their inconsistent behaviour and identity – is, as I explore above, crucial to the manner in which his films might engender a mode of reception which does not strive to 'know.' It does not seem to me that Lynch should be indicted on counts of sexism so long as these perceived reductive or essentialist representations of women are no more or less unknowable, mysterious and – crucially – in flux than any other representation in his films.

The latter point is acknowledged by Heather K. Love, who writes of how, despite *Mulholland Drive* certainly representing lesbianism through stereotype, it represents lesbianism through two stereotypes which are starkly in contrast. 'In the romance between Betty and Rita', writes Love, 'Lynch presents lesbianism

in its innocent and expansive form: lesbian desire appears as one big adventure, an entrée into a glamorous and unknown territory', yet in the story of Diane and Camilla, we are offered 'a classic lesbian triangle, in which an attractive but unavailable women dumps a less attractive woman who is figured as exclusively lesbian' (123). Love acknowledges that 'lesbianism is popularly understood as both the hottest thing on earth and, at the same time, as something fundamentally sad and not at all erotic' and so both these representations – 'the sexiest possible woman and...an abject and unwanted creature' - are stabilised within the dominant discourse (123). Yet they are necessarily kept at a distance (I doubt that, for instance, very many teenage boys fantasising about girls 'doing it' have masculinely coded same-sex female couples in mind). In *Mulholland Drive*, however, 'by casting Noami Watts as both Betty and Diane', Lynch 'scrambles...the comic and the tragic versions of female same-sex desire', providing the spectator with two – seemingly contradictory - articulations of lesbianism within the same film (Love, 123-124).

There is, however, no such mystery or confusion cultivated by the representation of the group of girls in *INLAND EMPIRE*. They are ostensibly demystified, and that which is 'revealed' is a gaggle of pre-given archetypes to which a spectator might cling in a film in which all other representations are unstable, a film in which insidious Poles in expensive coats are also trailer-park rednecks and butlers dance like cheerleaders. Put simply, these girls typify a stereotype and the film is consistent in this representation. No matter of their diegetic significance, their significance in a codified worldview is clear: they are teasing, sexualised nymphs who are always ready to bat their eyelids and sigh provocatively and who scream and disperse at the sight of blood.

With seeming naivety as to the dangers of taking the inverse position, Lynch categorically denies the notion that representa-

tions in his films might fuel stereotypes (tellingly using women as his first microcosm) when he asserts that 'it's dangerous…to say that a woman in a film represents all women…Some critics love generalisations. But it's *that* particular character in *this* particular story going down *that* particular road' (89). It is undeniable, however, that normative stereotypes sometimes appear in Lynch's work, for example the aforementioned streetwise hitman Joe in *Mulholland Drive*. However, such characters are rarely given as much screen-time as *INLAND EMPIRE's* group of girls, and often whisked away at the moment when the spectator thinks that he/she has finally got hold of a character type which he/she recognises and might unproblematically categorise. The group of girls in *INLAND EMPIRE*, however, reappear again and again in the same – or similar - incarnations, and are almost always centre of attention.

In answer to the question 'What does contemporary visual culture say about women?,' Nina Power refers to the so-called 'Bechdel Test', as described in Alison Bechdel's comic strip *Dykes to Watch Out For*. The 'Bechdel Test' 'consists of the following rules, to be applied to films:

1 Does it have at least two women in it,
2 Who [at some point] talk to each other,
3 About something besides a man. (39)

Power acknowledges that Charles Stross slightly extends #3, to read 'about something besides men or marriage or babies' (qtd in Power, 39), but this is unnecessary in reference to *INLAND EMPIRE*. In *INLAND EMPIRE*, these girls are virtually the only female characters to engage in substantial conversation - one could point to the mysterious exchanges between Dern and the Visitors, but this hardly constitutes conversation - and neither marriage nor babies enter into their discussions.

Take, for example, the scene immediately preceding the afore-

mentioned seemingly impromptu but meticulously choreo-
graphed dance routine to 'The Loco-Motion'. I always found the
representation of the group of girls in this scene somewhat
problematic in terms of this book's central thesis, but initially I
mitigated such doubts by noting that the audience were still kept
unsure as to these girls' identities, and originally planned on
analysing this scene above in such terms. Upon reflection,
however, I concluded that their lack of concrete identities is not
a sufficient saving grace. In the scene, the girls aren't dressed as
provocatively as in their later incarnation as prostitutes, and so
at the start they seem to be girlfriends. This assumption is
supported by the subject of their conversation: Kari's (Michelle
Renea) relationship, yet by the end of the scene it seems more as
if they are discussing potential clientele for that night. In either
incarnation, however, it is clear that they are only of significance
in relation to men, and - despite the ambiguity as to *who* these
girls are - there is never any doubt as to *what* they are.

The scene begins with a shot of Dern near to the room's
doorway, staring into space, and the scene intermittently returns
to shots of her, although she does not speak. We then cut to a
close-up of Kari lying on the floor. 'It's the shits', she says. 'I
really thought you would last, you two' muses another girl in
close-up. Dori (Kathryn Turner), sitting on a sofa with Lanni
(Emily Stofle) and Lori (Kristen Kerr), says 'I saw it coming', and
when Lanni and Lori look at her disapprovingly, she says 'I'm
sorry! I did!' Lanni then says 'You're full of shit Dori', and Lori
says, in a half-whisper, 'Sucks...' We then cut back to Kari, who
says 'He was the one. I really thought he was...y'know?', which
is followed by a off-screen voice saying 'So what? He's gone.' We
then cut to a closeup of Dori, who remarks that Kari should 'find
someone else', before cutting to Lanni, who says 'It's not easy
when you feel like shit', to which Lori responds sarcastically
with 'Awww...Baby...' and they laugh. We then cut to a close-up
of Dern and we hear two voices off-screen saying 'Tonight we'll

change that' and 'Yeah, tonight will be good.' We then cut to a shot of Lanni, Lori and Dori on the sofa and Lori says 'There's always a chance with tits like yours Kari' and we cut to Kari, who coquettishly replies with 'Thanks.' We then cut back to the sofa. Lanni says 'Tits...', Lori says 'Tits 'n' ass...', and Lanni lifts her top to reveal her breasts, saying 'These are gonna bring them in like slin.' The other girls remark favourably, informing her that her breasts are 'pretty' and 'sweet', before the dance sequence begins.

This final part of the exchange distinctly draws to mind Power's discussion of the manner in which breasts are commodified in contemporary culture. She writes of how 'breasts, and not their 'owner', are the centre of attention, and are referred to...as completely autonomous objects' and concludes that 'contemporary breasts resemble nothing so much as bourgeois pets: idiotic, toothless yapping dogs with ribbons in their hair and personalized carrying pouches.' (25)

That their conversation turns to questions of 'the one' is also remarkably pertinent in reference to the manner in which women are prevalently represented in contemporary culture. Subsequent to noting the pervasive 'obsession with 'the one' as the transcendent culmination of an entire romantic destiny' in films such as *Sex and the City,* Power writes:

There is no emancipation here, if all effort is ultimately retotalized into the project of 'the one'; if all discussions with 'friends' are merely mediating stepping-stones in the eschatological fulfilment of romantic purpose. Contemporary cinema is profoundly conservative in this regard; and the fact that it both reflects and dictates modes of current behaviour is depressingly effective, and effectively depressing. (40-41)

One might argue that the characterisation of these girls is so exaggerated in its clichés as to veer into parody, and is thereby not the mindless reproduction of dominant representations but an illustration of these representations' vacuousness. If this were

the case, however, this characterisation would nevertheless rely on positioning the spectator as elevated possessor of knowledge, and would have little to do with the more fundamental challenge to the dominant discourse and its normative modes of thought which throughout this book I posit might be cultivated by Lynch's work. As Mary Ann Doane writes, 'this state of affairs – the result of a history which inscribes woman as subordinate – is not simply to be overturned by a contemporary practice that is more aware, more self-conscious' (qtd. in Gidal, 49).

A central argument of this book is that the capacity of much of Lynch's work to destabilise the spectator and engender a mode of reception which does not – and does not strive to – 'know' means that – unlike the archetypal classic realist film – his films often certainly do not reflect or dictate modes of current – or any form of - behaviour as if these modes of behaviour were essentialist, despite adopting the formal tropes of classic realism. The presence of this group of girls in *INLAND EMPIRE*, then, is anomalous in such a film, a film which otherwise induces its spectator to experience it as 'an adventure of perception' more than any other in Lynch's oeuvre.

Conclusion

I begin this book's summation with the same words which Eric G. Wilson opens the last chapter of his book *The Strange World of David Lynch*: 'Lynch's work increasingly moves towards this conclusion: there are no absolute truths, only quick experiences' (63). Wilson, however, works from the assumption that a disavowal of pre-given norms is somehow ethically detrimental. He writes that 'this conclusion would appear to suggest nothing but…the idea that no enduring values pervade the universe', which - according to Wilson - 'is generally anathema, an extremely dangerous vision that leads in most cases to… a sense that anything goes' (163). It takes him an entire paragraph to assert that, perhaps, 'this idea that no permanent truths, no persistent essences, exist' is not necessarily a dangerous concept, and to instead muse that such essentialism might be 'a necessary corrective to fundamentalist positions, to religious imperialisms, to fanaticisms of all stamps' (Wilson, 163). As I posit above, however, there is no need to point to examples whose detrimental impact is so immediately obvious in order to condemn the notion of 'permanent truths and persistent essences', since these concepts are central to the dominant discourse, insofar as it hypostasizes the perception of a certain class and obfuscates or judges others accordingly.

As I explore throughout this book, despite such manoeuvres of the dominant discourse seemingly finding their correlate in the archetypal classic realist film, Lynch's work might engender the inverse mindset without wholly eschewing classic realist visual rhetoric, unlike the work of many filmmakers who *intend* to engender such a mode of reception. Drawing examples from many of Lynch's films, I delineate how, in his work, elements – characters, timespace, narrative, certain shot-compositions – which, when conveyed from the third-person perspective,

theoretically implicate the viewer in a position of stable omniscience, profoundly destabilise the viewer through the manner in which Lynch contextualises and combines them with techniques which derive from more experimental film praxis.

Wilson writes that finding 'ourselves stripped bare of any positive conclusions and thus extended into a...place where no clear knowledge exists...is the terrible preparation for an experience of the absolute, a gnosis of the divine' (134). I would instead argue the opposite, that finding ourselves in such a state directs attention towards that which is terrestrial, that which is tangible. The acknowledgement that received knowledge is just that - received - leads to the necessity to reconfigure – or reconceptualise - our relationship with the world: to appreciate things for what they actually are, rather than what 'everyone knows' them to be; to appreciate things as valuable in-themselves, rather than for some exchange value. Such a mode of reception leads us to 'recover our senses...learn to see more, to *hear* more, to *feel* more' (Sontag, 14) and - in a world whose dominant discourse obfuscates the suffering necessary for its perpetuation in the name of 'the way things are', invoking transnational absolutes whose supposed universality can only be fallacious - this cannot be a bad thing.

Endnotes

1 Or rather, potential omniscience, in that, while one may not know everything of the diegesis, one is comfortable in the knowledge that one *could*, were the film only to show it.

2 From the work of Bruno Corra (whose 1912 document of his foray into abstract colour film – the evidence of which is now unfortunately lost – *Abstract Cinema: Chromatic Music* is nominally self-explanatory) to the work of Len Lye, Norman McLaren and Stan Brakhage, who writes in his essay *Film and Music* that 'the first departures in [his] working-orders from "fiction" sources gave rise to an integral involvement with musical notation as a key to film...aesthetics' (Brakhage 78).

3 Schneider has written on Lynch's use of the horror genre's motifs in his essay *The Essential Evil in/of Eraserhead*.

4 Relevant here is the Brakhage-inspired opening sequence to David Fincher's *Seven* (1995), or the animated credits of Edgar Wright's *Scott Pilgrim vs. The World* (2010) which are so indebted to Len Lye and Norman McLaren.

5 Kubelka states that 'cinema is a projection of stills – which means images which do not move – in a very quick rhythm. And you can give the illusion of movement, of course, but this is a special case, [despite] film [having been] invented originally for this special case' (139).

Works Cited

Filmography

Un Chien Andalou. Dir. Luis Bunuel and Salvador Dali 1929.
DVD. BFI, 2004

Rose Hobart. Dir. Joseph Cornell. 1936. Film.

Meshes of the Afternoon Dir. Maya Deren. 1943. Film.

At Land Dir. Maya Deren. 1944. Film.

Les Oursins. Dir. Jean Painleve. 1958. DVD. BFI, 2007

Adebar. Dir. Peter Kubelka. 1957. Film.

Flaming Creatures. Dir. Jack Smith. 1963. Film.

Pierrot Le Fou. Dir. Jean-Luc Godard. 1965. DVD. Optimum
Home Releasing. 2008

Six Figures. Dir. David Lynch. 1966. DVD. Scanbox, 2008

Epilogue. Dir. Peter Gidal. 1975. Film.

Eraserhead. Dir. David Lynch. 1977. DVD. Scanbox. 2008.

The Elephant Man Dir. David Lynch. 1980. DVD. Optimum Home
Releasing. 2008.

Dune Dir. David Lynch. 1984. DVD. Prism. 2004.

Blue Velvet. Dir. David Lynch. 1986. DVD. Sanctuary. 2008

Wild at Heart. Dir. David Lynch. 1990. DVD. Universal Pictures
UK. 2010

'Coma' *Twin Peaks*. Dir. David Lynch. ABC. 6 Oct. 1990. DVD.
Universal Pictures, 2002

'Laura's Secret Diary' *Twin Peaks*. Dir. Todd Holland. 20 Oct.
1990. DVD. Universal Pictures, 2002

'Beyond Life and Death' *Twin Peaks*. Dir. David Lynch. ABC. 10
Jun. 1990. DVD. Universal Pictures, 2002

Twin Peaks: Fire Walk With Me. Dir. David Lynch. 1992. DVD.
2entertain. 2007

Lost Highway. Dir. David Lynch. 1997. DVD. 4front. 2002.

The Straight Story. Dir. David Lynch. 1999. DVD. Channel 4. 2008.

Mulholland Drive. Dir. David Lynch.. 2001. DVD. Optimum

Releasing, 2007.

INLAND EMPIRE. Dir. David Lynch. 2006 DVD. Optimum Releasing, 2007.

Bibliography

Adorno, Theodor W. *Aesthetic Theory.* Trans. Robert Hullot Kentor. London: Routledge, 1984. Print.

Adorno, Theodor W.; Horkheimer, Max. *Dialectic of Enlightenment.* London: Verso. 1997. Print.

Artaud, Antonin, 'Sorcery and the Cinema.' Trans. P Adams Sitney. Sitney. 49-51.

Barthes, Roland. 'The Metaphor of the Eye'. Trans. J. A. Underwood. Afterword. *The Story of the Eye.* London: Penguin Books. 2001. 19-128. Print.

Barthes, Roland. *Writing Degree Zero.* Trans. Annette Lavers and Colin Smith. London: Jonathan Cape. 1967. Print.

Bazin, Andre, 'The Myth of Total Cinema' Trans. Hugh Gray. Braudy, Cohen, Mast. 34-38.

Benjamin, Walter 'Theses on the Philosophy of History' Trans. Harry Zorn. *Illuminations.* Ed. Hannah Arendt. London, Pimlico: 1999. 245-256. Print.

Blu-riven; Vickie Balamoti; Wasto7 'Cast: Ed.' Lost on Mulholland Drive. 16 March 2011 http://www.mulholland-drive.net/cast/ed.htm

Bordwell, David. *Narration in the Fiction Film.* London: Methuen & Co. ltd. 1985. Print.

Butt, Riazat, 'Cameron calls for return to Christian Values as King James Bible turns 400' *The Guardian* 16 December 2011 http://www.guardian.co.uk/world/2001/dec/16/cameron-king-james-bible-anniversay

Brakhage, Stan 'Selections from *Metaphors on Vision'* McPherson. 11-73.

Brakhage, Stan 'Film and Music' McPherson. 78-86.

Braudy Leo; Cohen, Marshall; Mast, Gerald. eds. *Film Theory and*

Criticism 4th *Edition.* Oxford. Oxford University Press. 1992.

Buckland, Warren, 'Making Sense of Lost Highway' *Puzzle Films* Ed.Warren Buckland. Chichester: Blackwell: 2009. 42-62. Print.

Braziel, Jana Evans, 'In Dreams: Gender, Sexuality and Violence in the Cinema of David Lynch' Davison & Sheen. 107-118.

Cameron, David, 'Speech on the fight-back after the riots' *New Statesman* 15 August 2011 http://www.newstatesman .com/politics/2011/08/society-fight-work-rights

Caughie, John, *Television Drama: Realism, Modernism, and British Culture.* Oxford: Oxford University Press. 2000. Print.

Chion, Michel. *David Lynch.* Trans. Robert Julian California: University of California Press. 2007. Print.

Corra, Bruno "Abstract Cinema: Chromatic Music ." Futurism. 1912. 10 October 2010. http://www.unknown.nu/futursm /abstract.html

Davison, Annette & Sheen, Erica. eds. *The Cinema of David Lynch: American Dreams, Nightmare Visions.* London: Wallflower Press, 2004. Print.

Davison, Annette, "Up in Flames: Love, Control and Collaboration in the Soundtrack to *Wild at Heart* Davison & Sheen. 119-136.

Dayan, Daniel 'The Tutor Code of Classical Cinema' Braudy, Cohen, Mast. 179-192.

Deren, Maya, 'Cinematography: The Creative Use of Reality' Braudy, Cohen, Mast. 59-71.

Derrida, Jacques, *Specters of Marx* Trans. Peggy Kamuf .London: Routledge, 1994. Print.

Eisenstein, Sergei, 'Through Theater to Cinema' Trans. Jay Leyda *Film Form* Ed. Jay Leyda. London: Harcourt, Inc, 1977 3-18. Print.

Ehrenstein, David *Film: The Front Line 1984.* Denver: Arden Press, Inc. 1984. Print.

Frampton, Hollis. 'Interview at the Video Data Bank.' *the Camera*

and Consecutive Matters: The Writing of Hollis Frampton Ed.
Bruce Jenkins *On.* London: MIT Press. 2009. 183-190. Print.

Frye, Brian 'Rose Hobart.' Senses of Cinema. 2001. 15 October
2010 http://www.sensesofcinema.com/2001/cteq/hobart/

Gidal, Peter. *Materialist Film.* London: Routledge, 1989. Print.

Godard, Jean-Luc, *Godard on Godard.* Trans. Tom Milne New York:
Da Capo Press, 1972. Print.

Hainge, Greg 'Weird or Loopy? Specular Spaces, Feedback and
Artifice in *Lost Highway's* Aesthetics of Sensation' Davison &
Sheen. 136-151.

Heath. Stephen. *Questions of Cinema.* London: The Macmillan
Press Ltd. 1981. Print.

Hillier, Jim. *Cahiers du Cinema: The 1950s, Neorealism, Hollywood,
New Wave.* Cambridge: Harvard University Press 1986. Print.

Hughes. David. *The Complete Lynch.* London: Virgin. 2001. Print.

Jacobs, Ken. "The Joys and Sorrows of Effervescent Cinema."
Millennium Film Journal . Summer/Fall 2005. 11 November
2010. http://mfj-online.org/journalPages/MFJ43/KenJacobs
.htm

Jarvis, Simon. *Adorno: A Critical Introduction.* Cambridge: Polity
Press. 1998. Print

Jarmick, Christopher J. 'A Slow ride down Mulholland Dr' Senses
of Cinema July 2006. Accessed 15 December 2010
http://www.sensesofcinema.com/2006/cteq/mulholland-dr/

Jerslev, Anne, 'Beyond Boundaries: David Lynch's *Lost Highway'*
Davison & Sheen 151-165.

Kubelka, Peter, 'The Theory of Metrical Film.' Sitney 139-159.

Kracauer, Siegfried, 'From *Theory of Film'* Braudy, Cohen, Mast 9-
21.

Le Grice, Malcolm. *Experimental Cinema in the Digital Age.*
London: BFI Publishing. 2001. Print.

Love, Heather K. Spectacular Failure: The Figure of the Lesbian
in "Mulholland Drive" *New Literary History* Vol. 35, No. 1,
Rethinking Tragedy. Winter, 2004. 117-132.

Lynch, David; Rodley, Chris. *Lynch on Lynch*. London: Faber and Faber. 2005. Print.

Lynch, David. *Catching the Big Fish*. New York: Penguin. 2006. Print.

Maccabe, Colin, *Theoretical Essays: Film, Linguistic, Literature* Manchester: Manchester University Press, 1985. Print.

Mazullo, Mark 'Remembering Pop: David Lynch and the Sound of the '60s' *American Music* Vol. 23, No. 4. (Winter, 2005). 493-513.

McGowan, Todd, 'Finding Ourselves on a "Lost Highway": David Lynch's Lesson in Fantasy' *Cinema Journal*, Vol. 39, No. 2 (Winter, 2000), 51-73.

McPherson, Bruce R. Ed. *Essential Brakhage*. New York: McPherson and Company, 2001. Print.

Moore, Rachel, *(nostalgia)* Cambridge: The MIT Press, 2006. Print.

Nochimson, Martha P. *The Passion of David Lynch: Wild at Heart in Hollywood*. Austin: University of Texas Press: 1997. Print.

Nochimson, Martha P. 'All I Need is the Girl': The Life and Death of Creativity in *Mulholland Drive*' Davison & Sheen. 165-182.

Nochimson, Martha P. Inland Empire *Film Quarterly* Vol. 60, No. 4 (Summer 2007) 10-14. Print.

O'Pray, Michael, 'Modernism, Phantasy and Avant-Garde Film' *The Undercut Reader: Critical Writing on Artist's Film and Video* eds. Nina Danino and Michael Maziere. London. Walflower Press. 2003. 31-34. Print.

Power, Nina, *One Dimensional Woman*. Winchester: Zer0 Books. 2009. Print.

Rinder, Lawrence, 'Anywhere Out of the World: The Photography of Jack Smith' *Flaming Creature: Jack Smith, his amazing life and times* Ed. Edward Leffingwell, Carole Kismaric, Marvin Heiferman. London: Serpent's Tail. 1997. 139-152. Print.

Roche, David 'The Death of the Subject in David Lynch's *Lost Highway* and *Mulholland Drive*', *E-rea* 15 octobre 2004. 17

January 2011 http://erea.revues.org/432

Rombes, Nicholas, 'Blue Velvet Underground: David Lynch's Post-Punk Poetics' Davison & Sheen 61-77.

Rothman, William, 'Against "The System of the Suture,"' in Braudy, Cohen, Mast 192-199.

Schneider, Steven Jay, 'The Essential Evil in/of *Eraserhead*' Davison & Sheen 5-19.

Silverman, Kaja 'From *The Subject of Semiotics*' Braudy, Cohen, Mast. 199-210.

Sitney, P. Adams. ed. *The Avant-Garde Film: A Reader in Theory and Criticism*. New York University Press: New York. 1978. Print.

Sitney, P. Adams. *Visionary Film*. Oxford: Oxford University Press. 1979. Print.

Shklovsky, Victor. 'From *Art as Technique*' *Modernism: An Anthology of Sources and Documents*. Ed. Vassiliki Kolocotroni,; Jane Goldman; Olga Taxidou. Edinburgh: Edinburgh University Press. 1998. 217-221. Print.

Smith, Sharon, 'The Image of Women in Film: Some Suggestions for Future Research' Ed. Sue Thornham *Feminist Film Theory*. Edinburgh: Edinburgh University Press, 1999. 14-19. Print.

Sobchack, Vivian, *The Address of the Eye*. Oxford: Princeton University Press. 1992. Print.

Sontag, Susan, *Against Interpretation*. London: Andre Deutsch. 1987. Print.

Toles, George, 'Auditioning Betty in Mulholland Drive' *Film Quarterly*, Vol. 58, No. 1 (Fall 2004) 2-13.

Vine, Richard 'Eterniday: Cornell's Christian Science "Metaphysique"' *Joseph Cornell: Shadowplay Eterniday* eds. Lynda Roscoe Hartigan, Richard Vine, Robert Lehrman. New York: Thames and Hudson. 2003. 36-51. Print.

Wilson, Eric G., *The Strange World of David Lynch*. London: Continuum. 2007. Print

Yacavone, Daniel, "Towards a Theory of Film Worlds", *Film-Philosophy*, vol. 12:2 (2008), 83-108.

Yue, Genevieve, 'Jonas Mekhttas' *Senses of Cinema* February 2005. 5 February 2011 http://www.sensesofcinema.com/2005/great-directors/mekas/

Žižek, Slavoj. *The Art of the Ridiculous Sublime.* Washington: University of Washington Press. 2000. Print.

"Narrative" *Oxford Dictionary of English: Second Edition* eds. Catherine Soanes, Angus Stevenson. Oxford University Press: 2003. Print.

Contemporary culture has eliminated both the concept of the public and the figure of the intellectual. Former public spaces – both physical and cultural – are now either derelict or colonized by advertising. A cretinous anti-intellectualism presides, cheerled by expensively educated hacks in the pay of multinational corporations who reassure their bored readers that there is no need to rouse themselves from their interpassive stupor. The informal censorship internalized and propagated by the cultural workers of late capitalism generates a banal conformity that the propaganda chiefs of Stalinism could only ever have dreamt of imposing. Zer0 Books knows that another kind of discourse – intellectual without being academic, popular without being populist – is not only possible: it is already flourishing, in the regions beyond the striplit malls of so-called mass media and the neurotically bureaucratic halls of the academy. Zer0 is committed to the idea of publishing as a making public of the intellectual. It is convinced that in the unthinking, blandly consensual culture in which we live, critical and engaged theoretical reflection is more important than ever before.